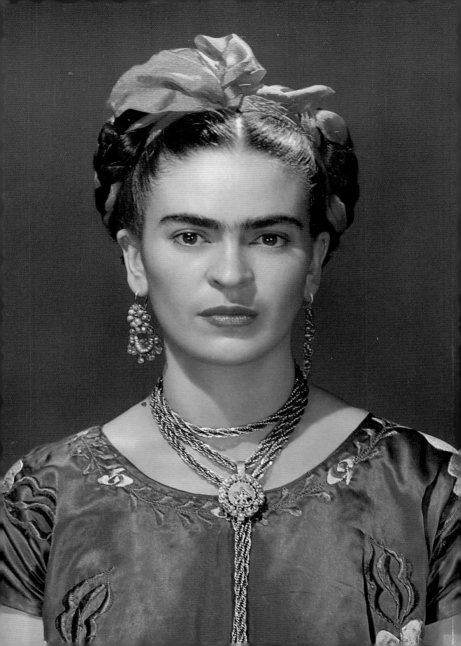

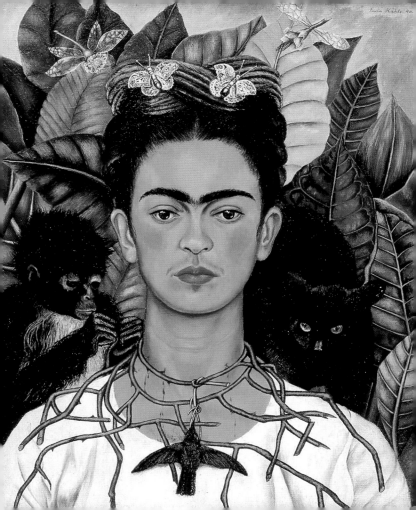

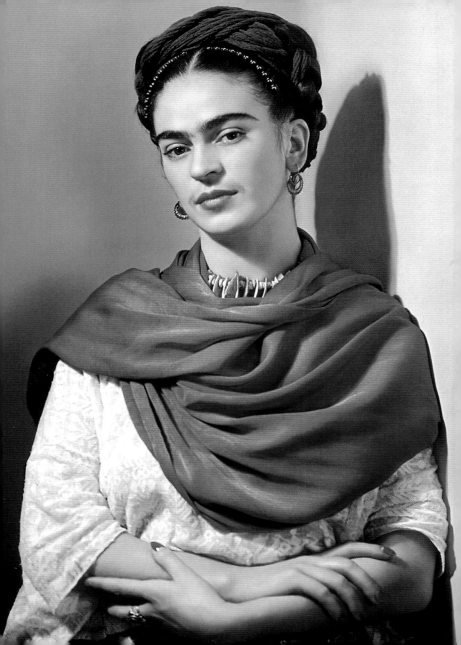

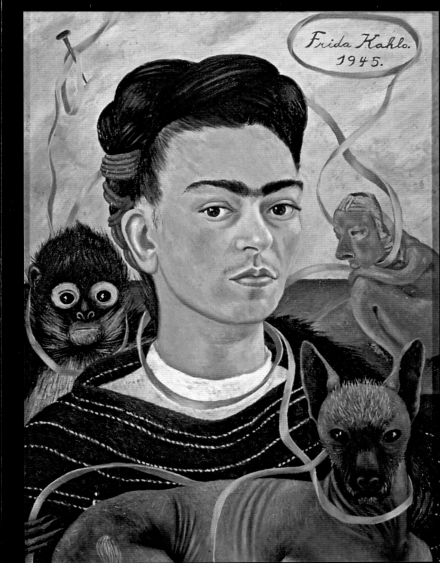

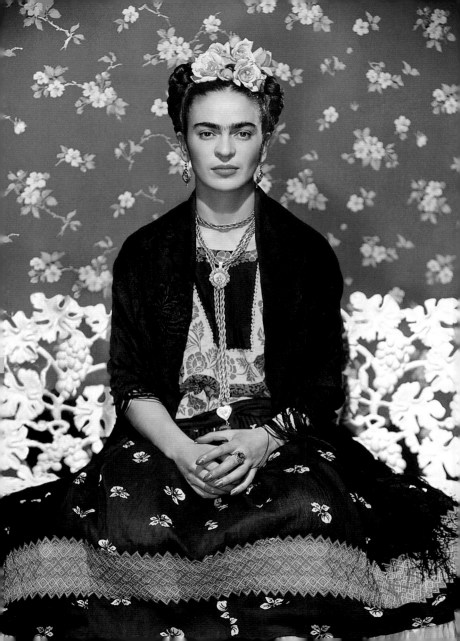

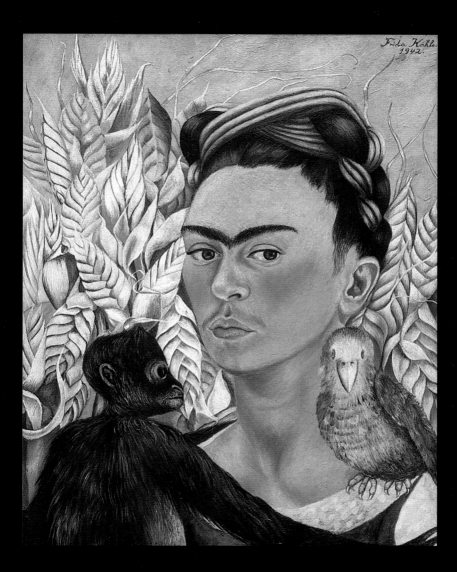

CONTENTS

FRIDA KAHLO

PAINTING HER OWN REALITY

CHRISTINA BURRUS

DISCOVERIES®

ABRAMS, NEW YORK

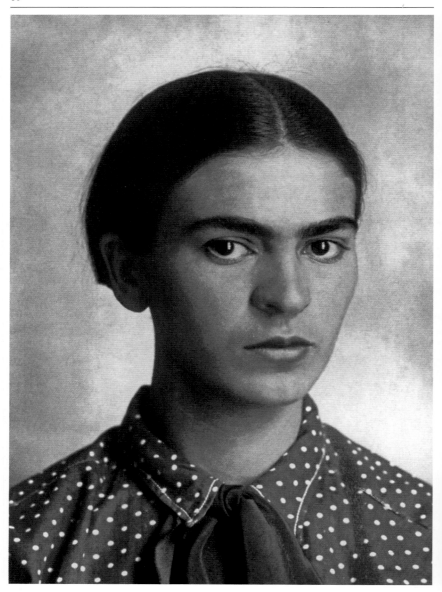

Oने morning in May 1890, an eighteen-year-old by the name of Karl Wilhelm Kahlo nimbly crossed the heavy wooden gangplank connecting the steamship *Borussia* with the pier in the German port of Hamburg. The ship's destination was Mexico, and although he didn't speak a single word of Spanish, the pale young German with the large hazel eyes was to father one of Mexico's 'national treasures' – the artist Frida Kahlo.

CHAPTER 1

VICTIM

Frida (opposite, at 19) would always be haunted by death and violence but remained strongly attached to life. The votive painting, right, represents her accident in 1925: 'Mr and Mrs Guillermo Kahlo and Matilde C. de Kahlo give thanks to Our Lady of Sorrows for saving their daughter from the accident in 1925, at the corner of Cuahutemozin and Calzada de Tlalpan.'

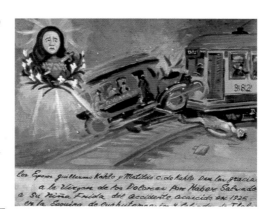

Los Esposos guillermo Kahlo y Matilde c. de Kahlo Dan las gracias a la virgen de los Dolores por haber salvado a su niña Frida del accidente acaecido en 1925 en la Esquina de Cuahutemozin y Calzada de Tlalpan.

My Grandparents, My Parents and I

Magdalena Carmen Frida Kahlo Calderón was born on 6 July 1907 in Coyoacán, a fashionable suburb in the south-west of Mexico City. Her father, Karl Wilhelm Kahlo (b. 26 October 1872 in Pforzheim, Baden-Württemberg) was born into a family of German jewellers but relations became strained following the death of his mother and his father's remarriage. A promising start as a student at the University of Nuremberg came to an abrupt end after a fall that induced epileptic fits. It was in the wake of these events that Kahlo decided to emigrate to Mexico, intent on making a new life for himself. He changed his first name, Wilhelm, to Guillermo and married a young Mexican girl, Maria Cardeña, with whom he had two daughters, María Luisa and Margarita. Maria died giving birth to their second child and Kahlo met his second wife, the beautiful Matilde Calderón y González, while they were both working at the La Perla jewellers in Mexico City. Matilde was born in Oaxaca to a staunchly Catholic mother, whose own father had been a Spanish general, and a father of indigenous Mexican descent from Morelia, who ran a photographic business that Kahlo took over. Kahlo had four daughters with his second wife: Matilde, Adriana, Frida and Cristina, who was eleven months younger than Frida. A brother named Wilhelm died at the age of one, before Frida was born.

Matilde Calderón suffered from a degeneration of the fallopian tubes and fell ill; she had just lost one child and Frida's was a difficult birth. Baby Frida was entrusted to an indigenous Mexican wet-nurse. The pattern of depressive episodes became chronic and it was the two eldest children, Matita (Matilde) and Adriana, who ended up looking after Frida and Cristina.

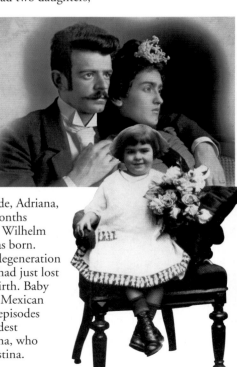

Below: Matilde, shown posing with her husband Guillermo Kahlo, was a tiny woman with beautiful eyes and a pretty mouth. The photograph of Frida at the bottom of the page was taken by her father and reveals clear family traits.

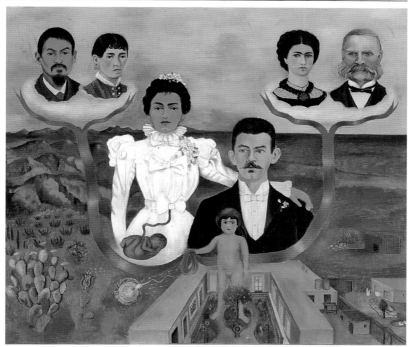

A Domineering Mother

Frida grew up in a household of women, in the Casa Azul – the beautiful Blue House on the corner of Calles de Londres and Allende, built by her father a few years before she was born. The house featured an internal courtyard and was run by Frida's domineering and depressive mother, 'el Jefe' (the Chief) as Frida called her. Frida's mother was the eldest in a family of twelve and had been obliged to look after her siblings. Having never known maternal affection herself, she had none to give, and she refused to take on Guillermo's daughters by his first marriage. The younger of the two, Margarita, was sent to a convent.

Matilde Calderón drew her strength from her Catholic faith. Grace was said at every meal time and the girls were dragged to church – the Church of Saint John the

Above: *My Grandparents, My Parents and I* represents Frida's family tree and was painted from photographs in 1936. The two sets of grandparents, to the left and right, seem to emerge from nowhere. Frida's parents are copied from a wedding photo and occupy the centre of the picture. Frida is shown as a child, naked and holding a broad red ribbon to indicate the link with her family. She is standing inside the Casa Azul.

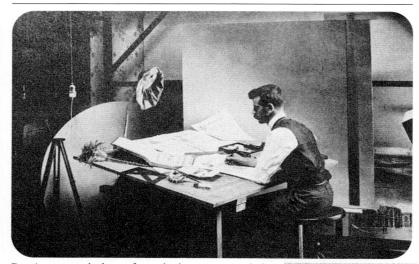

Baptist, a stone's throw from the house – on a daily basis and forced to go into retreat every Easter. 'My mother was fanatical about religion,' Frida would later comment. She was also very beautiful, with a lovely figure and exquisite eyes, and took great care over her appearance.

The children were taught the traditional arts of cookery, sewing, embroidery and housekeeping by Matilde, who was intelligent but illiterate – 'all she could do was count,' said Frida. However, she was also despotic and often neurotic, even cruel. Nowadays we would probably describe her as depressed. The young Frida almost certainly knew the source of all that pent-up frustration: she had seen her mother with a book bound in Russian leather, which contained all the letters from her first love, a young German who had committed suicide in front of her. Did she think she could turn back time by marrying another frail young German prone to epileptic fits?

Herr Kahlo

While her mother inspired a mixture of fear and longing in Frida, her father gave her warmth, affection and above

Top: Guillermo Kahlo in his studio. Elements of Frida's paintings are prefigured in this photo, including the solitary figure in a private moment and the somewhat theatrical setting.

Above: An advert for Guillermo Kahlo in *El Mundo Ilustrado*, 24 February 1901.

all the discipline of a Germanic education. She was mischievous with him, but affectionate, nicknaming him 'Herr Kahlo' for his stiff, solemn Germanness and his rather fastidious ways. Frida came to be something of a replacement for the son he had just lost, her father's heir, in whom he invested all his hopes. He saw to it that all the girls had Mexican nationality, but sent the two youngest to the German School in Mexico City.

Kahlo was already a distinguished member of the local community when Frida was born. Encouraged by his wife and by his success as an amateur in Mexico City's German community, he began working as an artist–photographer alongside his father-in-law and in due course was named 'first official photographer of Mexico's national cultural patrimony' by the dictator Porfirio Díaz (1830–1915).

Kahlo liked his routines. He would leave the house early each morning for his studio in the centre of town, carrying the lunch that Matilde had prepared for him, and return at the same time each evening. Then he would shut himself away with his German piano and play Beethoven or Viennese waltzes before dining alone, served by his wife.

He enjoyed chess and owned an extensive library which included works by Goethe and Schiller and German philosophers such as Nietzsche and, in particular, Schopenhauer. By his desk hung a huge portrait of the latter – a kind of spiritual father presiding over his affairs. Arthur Schopenhauer, author of *The World as Will and Idea*, was the dominant figure in the vision of life that Kahlo passed on to his daughter, who learnt at an early age that 'philosophy brings wisdom and helps us to assume our responsibilities'. Kahlo wanted his children to be silent and orderly, but every six weeks that silence and order were torn apart by his epileptic fits. As

Below: View of Mexico's National Theatre during its construction, taken in 1910. We could be in Paris but for the tiny figure in the sombrero. Mexico was remodelling itself along European lines: the avenues of Mexico City were being widened in imitation of the Champs-Élysées and neoclassical monuments reflected the academic style fashionable throughout the capitals of Europe. As Porfirio Díaz's official photographer, Guillermo Kahlo immortalized this world on the very brink of its dissolution.

these episodes were never explained, when they occurred the girls regarded their father as 'a frightening mystery'.

Polio Strikes

At the age of six Frida, the cheerful, fidgety child, whose chubby cheeks were always dimpled with laughter, entered a new and very different phase of her life – characterized by pain and round-the-clock medical care. 'It all began with a terrible pain in my right leg, which spread from the muscle down to my foot,' she said. She had contracted polio and for the next nine months would be confined to bed.

Frida recovered, but the illness had left her with a wasted leg and a limp which earned her the nickname *Frida, pata de pelo* ('peg-leg Frida'). The bright eyes of this slight child seemed blacker than before, and sometimes as if they were looking somewhere else entirely. Guillermo Kahlo took great care of his daughter during her illness. To help her regain her strength and build up her wasted muscles he devised an exercise plan, which was unheard of for the daughter of a well-to-do Mexican family at that time. She learnt to roller-skate and ride a bicycle – activities then reserved for boys – and went rowing with her father, played ball and wrestled. She loved climbing trees and became a real tomboy. The limp became less obvious, but her leg remained very thin, a fact she tried to conceal with layers of socks and high boots, and later trousers. Frida was tough and determined and learned to cope with her disability, but it left her feeling hurt, different from other children and lonely.

Above: *Portrait of My Father* (1951). The figures in Frida's paintings have the same slightly formal rigidity as the subjects in her father's photographs. There is a directness and a determination in the sitter's attitude that is free of complacency and was forged by a combination of life experience and a German education.

Opposite: Frida aged twelve, dressed as a typical European schoolgirl and hiding her thin right leg.

Nature and Darkroom

It was almost certainly the illness that brought Guillermo and Frida together. The experience had left Frida with a sense of solitude and shifted her focus away from the outside world, with all its hustle and bustle, towards an inner life, a deepening creative awareness. Guillermo taught Frida how to use a camera, and later how to develop, retouch and colour photographs. It was meticulous work, precise almost to the point of obsession. In the little girl, bent over her father's photographs, we catch a glimpse of the woman she was to become – utterly absorbed by her paintings (an oeuvre essentially made up of self-portraits); she would use the same small, very precise brushstrokes as she had used to retouch the photographs and a small, rigid stand, similar to a photographic one. And as she moved from glass plates to metal plates, darkroom to darkened bedchamber, it was always the physical impact of accidents to her body that helped her to develop that heightened degree of concentration.

Frida accompanied her father when he took his photographs. It was another opportunity to learn from him, but also to help him when he needed it: 'He would often be walking along with his camera slung across his shoulder, holding my hand, and suddenly collapse. I got to know how to help him when these attacks occurred in the street.' A guiding hand but a hand that also let go, which was always threatening to let go – here perhaps was the source of her constant fear of abandonment as a grown woman. These walks with her father also inspired in Frida a Romantic view of nature – which was to remain in her eyes the incarnation of life, of universality and of the natural cycle of things.

I had a wonderful childhood despite my father being ill. He was an extraordinary example to me in terms of tenderness and hard work, but most of all in his understanding of all my problems.'
Frida Kahlo, *Diary*

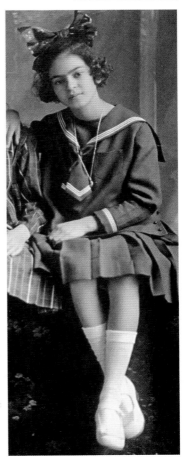

The *Cachuchas*

In 1922, Frida took a leap in the dark, leaving the security of her own neighbourhood each day to travel into the heart of Mexico City, an hour's tram ride away. She was one of the first girls – thirty-five out of two thousand students – to pass an examination admitting her to the Escuela Nacional Preparatoria, Mexico's top school. The school was responsible for grooming the country's future elite, and it was thanks to the policy of openness implemented by the new Minister of Public Education, José Vasconcelos, that it had just begun to admit girls. Frida was fourteen at the time and had chosen a five-year preparatory course before studying medicine. She was particularly interested in anatomy, biology and botany.

The young student created a sensation by turning up in a pleated navy-blue skirt, white socks, boots and plaits – full German schoolgirl regalia – just as, years later, she would sport indigenous Mexican dress in New York. She was making a statement, and the provocative, rebellious side of Frida Kahlo, her wish to affirm her freedom and difference, soon brought her into contact with those brothers and sisters who were to become her true family – the *Cachuchas*, seven boys and two girls (including Frida), who wore peaked caps (hence the name) designed by the famous couturier José Gómez Robleda as their distinctive badge. In the company of her new friends, Frida used slang expressions that she had picked up from the peddlers in the *zócalo* (main square of the city), consolidated her instinctive resistance to authority and developed a sense of loyalty and a tough, masculine notion of friendship – characteristics that were to remain with her throughout her life. The *Cachuchas* were known for their intelligence and high spirits; they also had a reputation for hoaxes and practical jokes and were masters of disruption – letting off firecrackers, for example. Their ideological cocktail was composed of a variety of ingredients – Socialism, Romanticism and nationalism – and they chose as their headquarters the Latin American Library, a few yards away from the 'Prepa' and the *zócalo* at the centre of Mexico City.

Below: Photograph of the young girls of Coyoacán in front of Jacobo Valdés's house, *c.* 1921. Cristina Kahlo is seated in the front row (far right). Frida is on the right of the third row. Pictured with her are her friends Lucha Valdés, Consuelo Navarro, Etelvina, Monserrat and Lourdes Canet, Isabel and Antonieta Campos, Ninfa Garzía, Lupe Rubí, Consuelo Robledo and Pax Fariña.

The group's raison d'être was political and intellectual. Its members exchanged reading materials, discussed literature and politics, recited poems and organized lectures and plays as a means of raising funds. The *Cachuchas* were all set on an identical quest, with their passion for poetry and literature perhaps overshadowing their interest in politics. All of them would embrace liberal professions in later years, but for the moment these disciples of Vasconcelos were keen simply to breathe in the air of the new age –
the age of a new truth,
of Mexico's rebirth,
of its self-discovery.

It is not absolutely clear which school Frida attended before being admitted to the Escuela Nacional Preparatoria in 1922. It was probably Mexico's German School, the Oberrealschule, which she would have left in 1921. Despite her early

German schooling, Frida complained later that her German was poor.

Above: Undated letter from Frida to Alejandro Gómez Arias, a friend at the Escuela Nacional Preparatoria and Frida's first boyfriend. The drawing shows her journey into Mexico City from the family home in Coyoacán, a few kilometres away.

Growing Up With Mexico

The *Cachuchas* were children of the revolution, which Frida herself affirmed when she changed the year of her birth (1907) to 1910 – the start of the Mexican Revolution. The Mexican Revolution was the first social revolution, marking the beginning of modern times in Mexico, and heralded Russia's October Revolution (1917).

It was the Democrat Francisco Madero (1873–1913) who started an uprising against Porfirio Díaz's dictatorship on 20 November 1910. Ten years of civil war followed, during which a million lives were lost. Madero had the support of Pancho Villa and his guerrilla armies in the north, as well as Emiliano Zapata, 'The Attila of the South', leader of a revolutionary peasant movement fighting under the slogan 'Land and Liberty' and typically depicted with a machete in his hand and a Guadalupe Virgin pinned to his sombrero. Madero gained power in 1911, only to face hostilities from both the Zapatistas, who were demanding the immediate distribution of land to the peasants, and the Conservatives under General Huerta. Madero was overthrown by Huerta and assassinated in 1913. Then Maderista Venustiano Carranza (1859–1920) formed an alliance with Zapata and Villa in an attempt to resume power but was assassinated by one of his generals, Álvaro Obregón, who finally put an end to these ten years of bloody conflict by assuming the presidency in November 1920.

Obregón immediately appointed the writer José Vasconcelos as Minister of Public Education. Mexico was a country in tatters and it was Vasconcelos's aim to restore a sense of national identity through a programme of

Below: While Porfirio Díaz was president, Mexico's indigenous culture, art and folklore were held in the utmost contempt. Each morning the dictator plastered his face with a thick layer of rice powder in order to conceal his own origins – and refashion the mask of the country's colonizers. Ninety-seven per cent of the country was divided between several thousand major landowners, and North America and Europe had control of the country's industry. Most of Mexico's artists had fled to Europe in search of political and intellectual freedom.

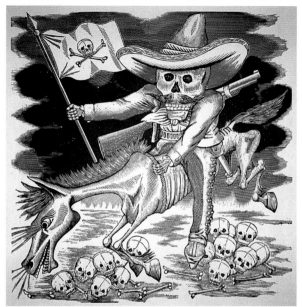

Left: Around this time, the streets of Mexico were full of satirical images by the political cartoonist José Guadalupe Posada, whose influence can be detected in both Frida's and Diego Rivera's work. Here, Posada underlines the wide-scale slaughter that resulted from the Mexican Revolution by depicting Emiliano Zapata, leader of the peasant movement in the south, with a skull head and his extravagantly whiskered moustache, wearing the revolutionary red scarf.

Below: Francisco Madero, who overthrew Porfirio Díaz in 1911, was himself assassinated two years later, during the *Decena trágica* ('The Ten Tragic Days') of the Mexican Revolution.

educational reforms that would eradicate the problem of illiteracy and revive public interest in Mexico's history and indigenous culture. He was keen that art and education should serve the common people, rejecting the European influences imposed by Díaz during his thirty-five-year dictatorship in favour of native intuition and the vernacular tradition. The indigenous Mexican became an emblematic figure, and a return to indigenous culture a means of restoring Mexico's roots. Everyone wanted traditional handicrafts. Traditional dishes appeared on the most staunchly middle-class dining tables, and regional costumes were the new fashionable city dress. European models

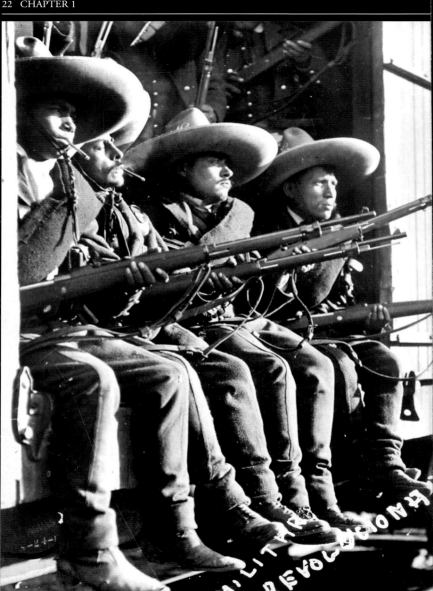

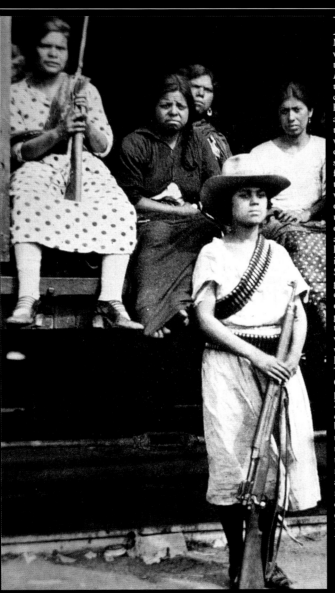

It was not just the men who were involved in Mexico's bloody battles: women fought alongside them. Much later, in her *Diary*, Frida replayed the events of those years, confidently projecting herself back into the action: 'I remember that I was four years old when the *Decena trágica* occurred. I actually saw Zapata's peasants fighting Carranza's troops. I had a good view of what was going on. My mother opened up the balconies overlooking Allende and let wounded and hungry Zapatistas come into the drawing room. She nursed them and gave them little maize cakes, which was the only food you could get in Coyoacán at the time.... In 1914, bullets were whizzing past the whole time. I can still hear their shrill whistle. The market square in Coyoacán was full of propaganda supporting Zapata. You could get *corridos* [narrative songs] by Posada there.... I used to sing them shut up in a big wardrobe that smelt of walnut. My mother and father were always very careful to make sure the guerrillas didn't get their hands on us during that time.'
Frida Kahlo, *Diary*

were rejected with the same vigour that had once been poured into slavish imitation. Mexico was reinventing itself. It became a crossroads for artists returning from foreign sojourns with a wealth of experience behind them, a hive of creativity and innovation.

Recession

Díaz's fall from power had dire financial consequences for Frida's family. The official commissions stopped and Guillermo was obliged to look for new clients – not an easy task in the straitened economic conditions of a country recently torn apart by civil war. The family tightened their belts, sold their French furniture and mortgaged the house. The children made their own contributions and in her free time Frida did a number of odd jobs: she kept the books in a sawmill, worked on the cash desk in a pharmacy, learnt shorthand typing and got a job in a factory. The most formative period was the time she spent working for a friend of her father, Fernando Fernández, a respected commercial printmaker, who taught her how to draw and was the first to recognize her artistic talent. Frida was developing in other ways too at this time. She was sexually precocious, eager for the freedom to do as she liked, and used every stratagem she could devise to escape her mother's watchful eye. She even confesses to being 'easy' in a letter to Alejandro Gómez Arias, the leader of the *Cachuchas*, her boyfriend and first love: 'I'd like to be even easier – something for you to keep under your hat for always and always,' she wrote on 25 December 1924 in a tone that was part provocative, part remorseful.

17 September 1925: The Accident

In the late afternoon of 17 September 1925, Frida caught the bus with Alejandro: 'I sat down at the side, next to the handrail, and Alejandro sat next to me. A moment or two later, the bus collided with a tram on the Xochimilco line. The bus was crushed by the tram on the street corner. It was a peculiar sort of impact. It wasn't violent. It was muffled and slow and it injured everyone. Me most of all…. The impact hurled us forwards and the handrail went into me like a sword going into a bull. A man,

This drawing entitled *The Accident* represents the pivotal event upon which Frida's oeuvre is based. Dated 17 September 1926 (exactly one year after the accident), it was drawn during a spell in hospital. Vigorous

seeing the way I was bleeding so badly, picked me up and laid me on a billiard table until the Red Cross arrived. I lost my virginity. My kidney went pappy. I couldn't pee any more. But the thing I complained about most was my spine.'

Alejandro relived the scene in slow motion. It was as if the bus itself had become elastic when the tram carriages struck it and kept on bending in the middle, bending

pencil marks give a sense of the violence – we can almost hear the grinding of tangled metal – while Frida herself reminds us of the Sleeping Beauty.

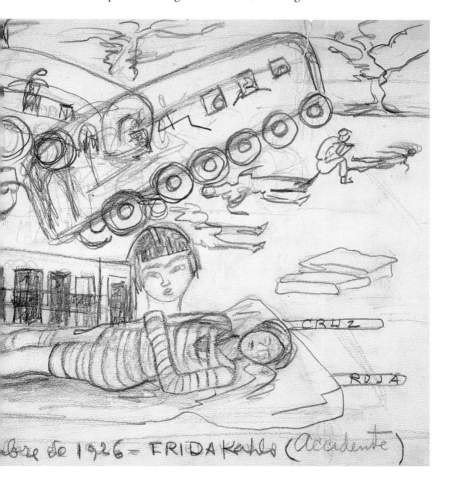

but not breaking, until '[it] had reached its maximum degree of flexibility and burst into a thousand pieces and the tram kept advancing. It crushed a lot of passengers.' The baroque vision that follows is strange and cruel, like a moment in a fairytale. 'Something surprising occurred then. Frida was completely naked. Her clothes had vanished in the collision. One of the passengers, most probably a painter…, had got on with a packet of gold dust. The packet was open and the dust spilled all over Frida's bleeding body.' She had sustained a whole series of injuries: a triple fracture to the spine, a fractured collarbone, fractures to the third and fourth ribs, dislocation of the left shoulder, a triple fracture of the pelvis, a perforated abdomen and vagina, eleven fractures to the right leg and dislocation of the right foot. The doctors at Mexico City's Red Cross Hospital went through the motions, knitting the pieces back together, all the time convinced that Frida would die on the operating table or from post-operative complications. They were underestimating their patient – her extraordinary capacities of endurance and her sheer will to live. Frida woke up. She was hungry and she wanted to see her family. Her mother lost her voice for a month from the shock and never visited at all, and her father, ill with grief, did not go for three weeks. The only family member to keep Frida company was her older sister Matita, who had run away from home with Frida's help at the age of fifteen to live with her boyfriend and had been banned from the house as a result (it was twelve years before their mother would speak to her again or allow her over the

Alejandro Gómez Arias (opposite, painted by Frida) was the artist's first love. Their relationship, which began at the Escuela Nacional Preparatoria in 1925 and lasted until 1928, produced an extensive correspondence.

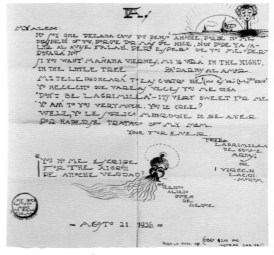

Above: A letter from Frida to Alejandro dated 21 August 1926.

threshold). Matita chatted, did her knitting, helped the nurses, and generally rallied the troops.

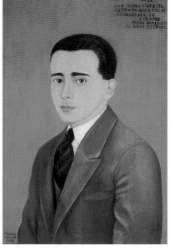

Once she was in a fit state to hold a pencil, Frida began writing to Alejandro. Her strength of character, her courage and her sense of humour shine through in these letters. 'Tuesday 13 October 1925. Alex *de mi vida*, you know better than anyone how sad I'm feeling in this pigsty of a hospital: you can picture it and friends will have told you. Everyone says I mustn't despair, but no one knows what it means to me to spend three months in bed. It's just what I need after wandering the streets.' *Callejera* (literally, 'person who likes walking the streets') is the Spanish word she uses. 'But what can you do? Hey, at least *la Pelona* ['the Bald One', i.e. Death] hasn't come for me!'

During the day, between visits from friends from the 'Prepa', she read a great deal. She read works by the 8th-century Chinese poet Li Po. She immersed herself in Henri Bergson's philosophy of the *élan vital*. She read Proust, Zola, Jules Renard, articles about the Russian Revolution and

A bove: This *Portrait of Alejandro Gómez Arias* was painted in 1928, probably from a photograph. It has a certain stiffness, but the young man's eyes are also rather melancholy and suggest insecurity. Frida kept the picture for herself, only giving it to Alejandro in 1952, two years before she died.

works on artists such as Cranach, Dürer, Botticelli and Il Bronzino. But when night fell she was haunted by a violent surge of images, part of a kind of internal photographic record of the disaster, images of a survivor convinced that death would come back for her too and reunite her with the others: 'In this hospital, death is dancing around my bed all night long,' she confided to Alejandro. And yet 'Alex *de mi vida*' did not come to see her either: for health reasons, he too was initially housebound.

A Four-poster Bed, a Mirror and Some Paints

Frida left hospital a month later, on 17 October. 'I'm happier now because I'm home with my mother…,' she writes. There followed a lengthy period of convalescence and immobilization in a succession of plaster corsets. It took the eighteen-year-old three months to recover, but a year later she suffered a relapse due to the negligence of the doctors, who had failed to examine her spine properly before discharging her from hospital, and perhaps also due to her parents' lack of funds for procuring all the necessary treatments.

Frida's mother installed a four-poster bed in her room, attached a mirror to the underside of the canopy and had a special easel made for her, and her father gave her a box of paints. Closeted in her tiny chamber of mirrors, Frida had very few visits from her friends from the 'Prepa' – Coyoacán was too far from the centre of town – and the ever more elusive Alejandro only came once, despite her increasingly desperate appeals: 'Alex, come quickly, as quickly as you can. Don't be so unkind to your *chamaca* [little one], who loves you so much.'

Below: Guillermo Kahlo positioned his favourite daughter at the centre of this photo, as if to take the place of the son he never had. It was only five months after the accident and she had barely recovered from her injuries. She hides them under a suit, looking back at the camera with a confident, slightly provocative air, and a hint of dandyism, a true *Cachucha*. To her right are her sister Adriana and her cousin Carmen; to her left, her younger sister Cristina and the young Carlos Veraza.

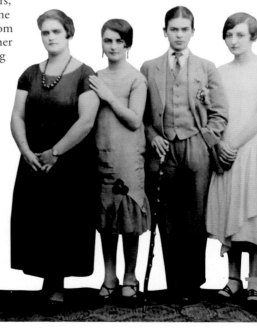

When Frida left her room, it was only to go as far as the patio, where her parents moved her bed so that she could be in the sun for a while. There was no question of Frida continuing her studies. Her sole apprenticeship now was to herself, the person she saw in her portrait-sized mirror. The only human subject was herself, since she was in no position to approach anyone else – though all around her were versions of the human face painted by the great German and Italian portraitists. This confrontation with her own identity raised a number of issues that were central to the whole artistic process: issues to do with illusion and duplication and the relationship of the self with death. More telling than any autobiography, Frida's self-portraits were to provide the 'internal images' of a woman launched on a quest that was as much existential as aesthetic, images of a conscious being in the process of becoming, of a burgeoning awareness of self and world. Her first effort at self-definition was the *Self-portrait Wearing a Velvet Dress* of 1926, showing a dignified, somewhat reserved Frida, whose strength and fragility are equally apparent in the picture. The painting is dedicated to Alejandro, whose family sent him to continue his studies in Germany – and to get him away from Frida. Alejandro would not return to Mexico until the end of 1927.

Above: Frida's *Self-portrait Wearing a Velvet Dress* (1926) was her first significant work. She started it shortly after the accident, and the work was interrupted several times by relapses. Frida had immersed herself in the imagery and lives of Renaissance painters during her convalescence, which imbue this self-portrait. But there is also a genuine sense of modernity, and what we can describe as the first manifestation of the Kahlo style.

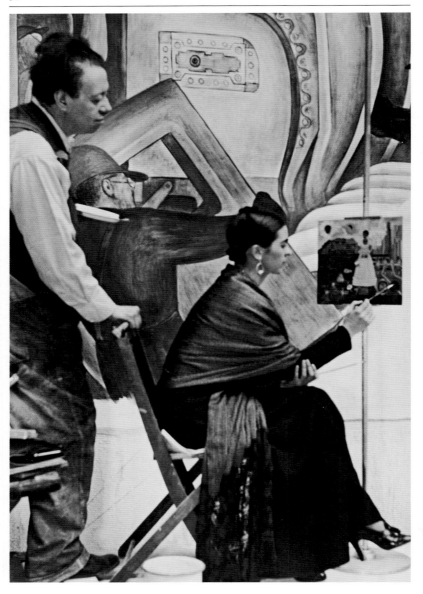

'I was at work on one of the uppermost frescoes of the Ministry of Education building one day, when I heard a girl shouting up to me, "Diego, please come down from there! I have something important to discuss with you!" On the ground beneath me stood a girl of about eighteen. She had a fine nervous body, topped by a delicate face. Her hair was long; dark and thick eyebrows met above her nose. They seemed like the wings of a blackbird....'

Diego Rivera, *My Art, My Life*

CHAPTER 2
NEW IDENTITY

Opposite: Frida in Detroit, working on *Self-portrait on the Borderline between Mexico and the United States* (1932), in which she expresses a profoundly Mexican sense of identity.

Right: With her new identity came a new way of painting for Frida. The wedding portrait, *Frida and Diego Rivera*, was painted in 1931 in the style of popular art.

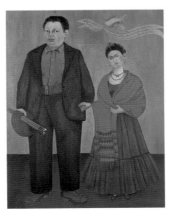

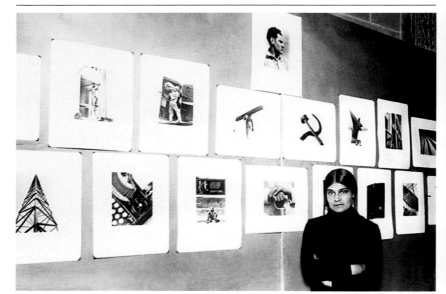

The Red Brooch

When Frida finally emerged from her plaster cast
it was like coming out of a mould, and months of
immobilization had given her a huge appetite for life.
In her physically weakened state, practising medicine was
no longer a viable option and Frida decided to abandon
her studies and devote herself to her painting instead.
Her first consideration, however, was to find work, since
her father was having increasing difficulty shouldering
his responsibilities as head of the family and the months
in hospital had placed a heavy financial burden on the
household. Frida resumed contact with her former
friends from the 'Prepa', who were now pursuing their
various studies and political interests at the university.
The student leader, Germán de Campo, took her under
his wing, still loyal to an old friend, who, at twenty, was
just coming back into the fray, wiser for her experiences
and eager to give her life meaning. With Germán, Frida
plunged into Mexico's artistic milieu, which was heavily
involved at the time with the Communist cause, and

'The art of the
Mexican People
…belongs to the people.
It is great and because it
belongs to the people it
is collective.' This was
the first affirmation of
a collective art, the work
of a group whose aims
are recorded in a 'Social,
political and aesthetic
declaration' signed by
Rivera, Orozco, Charlot
and others in the name
of the newly created
Union of Technical
Workers, Painters
and Sculptors. Rivera
was commissioned to
produce a mural project
(opposite) for the
Ministry of Education,
a job that was to take
him five years.

took as her model a young couple who embodied the union of art and politics: the press photographer Tina Modotti (companion and assistant of the famous American photographer Edward Weston) and her lover, the romantic young Cuban revolutionary Julio Antonio Mella, an opponent of the dictator Machado and first secretary general of the Cuban Communist Party, who was to be assassinated a few months later at Tina's side by one of Machado's agents.

Frida's admiration for the couple brought into clearer focus two aspects of Frida herself: her revolutionary idealism – the desire to give her life to the cause of justice – and her burgeoning awareness of her own femininity. Tina Modotti, the beautiful Italian-born revolutionary, represented in her eyes the feminine ideal, a woman free to make her own intellectual choices and free to do with her body as she chose, sincere both towards others and towards herself, a woman who placed her art in the service of the people's cause. Frida joined the Mexican Communist Party (PCM) and Tina gave her an enamel brooch, a hammer and sickle, which she pinned herself on to the black blouse of a woman who had by now exchanged her asexual outfits for long skirts and blouses and recovered the empowering sense of her own beauty.

B elow: This immense cycle entitled *Idyllic Political Vision of the Mexican People* (1923–28), is made up of a number of panels whose total surface area is 1,585 m² (1,896 yd²). It spans three stories, covering internal arcades, stairwell and lift, and begins with a succession of scenes from Mexican daily life relating to work, festivals and feast days, theatre, and the tyranny exercised by the rich over the poor. Kahlo (in the centre) and Tina Modotti (on the right) were both sympathetic to this *Vision*.

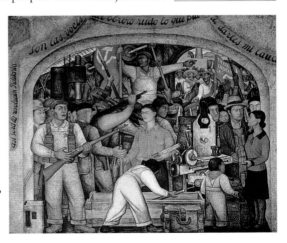

'Diego, Come Down!'

It was at Tina's house that Frida met Diego Rivera. Tina was the muralist's model for the fertility goddess in the frescoes entitled *Song to the Earth and to Those Who Work and Liberate the Earth* in the ancient chapel of Chapingo. Diego was over forty, more than 1.8 m (nearly 6 ft) tall, and weighed 150 kg (330 lb). He was one of the

O pposite: Tina Modotti at an exhibition of her photographs at Mexico's National Library in 1929.

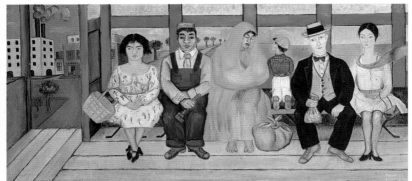

Tres Grandes – with José Clemente Orozco and David Alfaro Siqueiros – entrusted by José Vasconcelos, Minister of Public Education, with the task of educating the Mexican people (eighty per cent of whom were illiterate) and helping to restore a sense of Mexican identity by recounting the country's history on the walls of its public buildings. The story goes that the young Frida Kahlo had already stood in the Simón Bolívar amphitheatre, in Mexico City's Escuela Nacional Preparatoria, at the foot of the scaffold where the master of the muralist revolution was working on *The Creation*. Today, at any rate, she was heading for the Ministry of Education, stepping out briskly, her paintings under her arm, full of renewed energy after her recent brush with death. Diego was up on the third platform and she shouted to him: 'Diego, please come down from there!' Diego was taken aback. He obliged her, somewhat grudgingly, when she asked him to look at her work and was immediately struck by what he was to describe as the fundamental plastic honesty of the paintings, which had an artistic personality of their own. Frida told him calmly why she had come – not to get showered with compliments, but in the hope of seeking criticism from someone serious. Neither an art lover nor an amateur, she was simply a girl who needed to work for a living, she said. She asked him to come to her parents' house in Coyoacán the following Sunday to see the rest of her work and Diego needed no persuading: it was to

Above: In *The Bus* (1929) Frida Kahlo is offering – on a greatly reduced scale – the sort of social commentary we often find in Diego Rivera's murals. The painting lines up a series of Mexican stereotypes: a housewife with her shopping basket; a workman dressed in overalls and carrying a monkey wrench; an indigenous Mexican wrapped in her yellow *rebozo* and breastfeeding her baby; a little boy gazing out of the window; a pale-faced man, the gringo clutching his bag of money, equivalent of Diego's capitalist model; and a rather snooty-looking bourgeoise sporting a scarf and a fashionable bag. What we have here is the portrait of a social, Rivera-style hierarchy, but a portrait characterized by a brand of humour that is very much Frida's own.

be the beginning of a dialogue that would last for almost thirty years.

There had already been a number of women in Diego's life, including María Gutiérrez Blanchard, whom he met in Spain, the Russian Angelina Beloff in Paris, Marevna Vorobev-Stebelska, and the sensual and fiery Lupe Marín, his model for *The Creation* and his then-wife, by whom he had two children. Diego's response to this little slip of a girl 'from the provinces' was one of astonishment, admiration and respect: it was a response that was to remain undimmed by time.

The Elephant and the Dove

Diego accepted the role of boyfriend. He divorced Lupe and, at forty-two, became engaged to Frida – to the

Below: Diego and Frida took part in the Festival of Work demonstration with members of the Union of Technical Workers, Painters and Sculptors in Mexico City's *zócalo*, on 1 May 1929. The union, whose members included Rivera, Orozco, Siqueiros and Charlot, was the vehicle of the muralist revolution and had its own newspaper, *El Machete*.

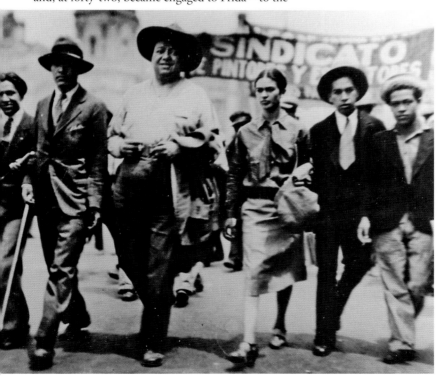

disgust of her family, whose condition was inferior to his own, whose objections he – the great Diego – was obliged to try to overcome and whose debts he would possibly have to pay off. 'Don't forget', Frida's father warned him, 'that my daughter is ill and that she will be ill all her life. She's intelligent, but she isn't pretty. Think about it if you will, and if you do wish to marry her, I give you my permission.' Frida was to be *the* woman in Diego's life and he had already immortalized her in his mural for the Ministry of Education, where she is depicted with a red star on her breast. The couple were married on 21 August 1929. Frida's family described it bitterly as the union of 'an elephant and a dove' and the only family member present at the wedding was Frida's father. Diego was dressed in American style and wore a huge Texan hat, and Frida appeared in indigenous Mexican dress, with puffed-out skirts and the *rebozo*, the traditional shawl, draped around her shoulders. Diego recounted later that 'Don Guillermo Kahlo stood up' right in the middle of the ceremony at Coyoacán's town hall 'and announced: "Gentlemen, this has to be a comedy, doesn't it?"' Was this a father's way of severing himself from his favourite daughter or a premonition of a married life that was to be a mix of laughter and tears, difficulties and contradictions? '*A ver qué sale*' – 'Let's see what comes of it' – wrote a rather more philosophical Tina Modotti to Edward Weston.

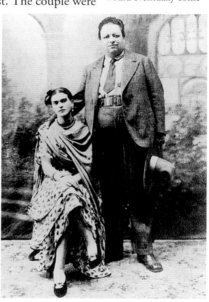

Below: Frida and Diego on their wedding day. Diego was almost twice her age and already married to Lupe Marín when Frida met him. She had had to fight hard to win him, and once they were married she worked at developing her own potential, so that she would eventually come to match Diego in artistic stature.

Opposite: Frida in a style of dress that reflected the trend towards Mexicanism, with long skirts and heavy jewelry, fringed shawls and a 'crown' of braided hair.

Her Life Became Art

The couple set up home in Cuernavaca, where Diego was working on *Conquest and Revolution*, a mural in the form of a fable that he was painting on the walls of the Cortés Palace. Diego himself was something of a monument, a piece of Mexican history, twenty years

Frida's senior, 20 cm (8 in.) taller than her and 100 kg (220 lb) heavier. He was her god, her son, her father, her 'second accident', as she liked to call him, and at his side she would create an oeuvre that would serve as a monument to her own life.

When Diego was expelled from the PCM, Frida resigned out of loyalty. And rather like a woman taking the veil, she dressed now, for his benefit, in the shimmering traditional costume of the women of Tehuantepec. Diego had visited the isthmus and remembered (and had recorded in paint) the beauty of its women, the proud and independent Tehuana, the queenly heads of a society run on matriarchal lines. He was also struck by the beauty of their costumes and headdresses, and for the rest of her life Frida would adopt the same morning ritual, decking herself out like an idol, fashioning her own image, defining a style of dress whose links with her pictorial style would soon become apparent. There was something Romantic, too, in her approach, which was perhaps as much German as Mexican, inspired by an authentic longing for *Heimkehr*, to return to her roots, to rediscover *mexicanidad* in a country that was reasserting its own indigenous values over those of Europe and North America. Frida began a new dialogue with her mirror, seeking the missing image of her German origins. Her life became art, and in embracing her vocation as a woman she was also embracing her vocation as an artist. She was the wife of '*el discutido pintor*' and made herself beautiful for him, took immense care over his meals, organized and inspired his everyday life; but she in turn drew from her husband's formidable energy and from his social recognition the conviction that she would

be a painter too, and that she would make a living from her art. It was Diego who would steer and encourage this inner belief through his own example, by a creative vigour that seemed to have no bounds and animated his entire existence: Diego, who in the space of four years had already covered 124 mural panels – or 500 m² (598 yd²) – to the glory of popular Mexican culture, the tangible expression of his passion for life and for beauty. Frida was expecting a baby at this time, but was forced to have a termination, and as an addition to the couple's collection of pre-Columbian figurines (now in the Anahuacalli Museum), Diego was to acquire a Nayarit fertility goddess, a figure of Aztec art associated with both life and death. After her accident, Frida had been advised against trying to carry a child to term. She defied the doctors on three occasions, and each time her body had the final say.

San Francisco

Perhaps to help them forget the trauma, the couple left Mexico and went to San Francisco, where they disembarked on 10

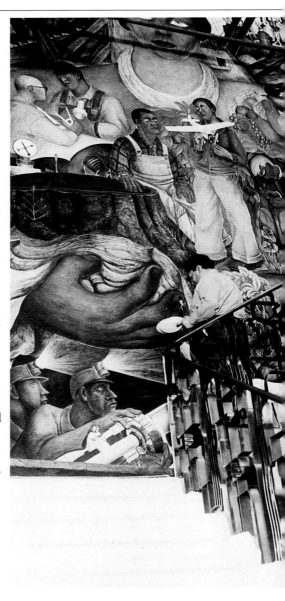

November 1930. Diego too had suffered repeated setbacks, paying the price no doubt for his success and his spirit of independence. A trip to the Soviet Union had ended in disappointment when Stalin's government dropped his proposed mural project. He had been excluded from the Mexican Communist Party's Central Committee. A number of friends had let him down badly. And he had been obliged to give up the directorship of the Academia de San Carlo on the grounds that his teaching was too revolutionary. It was the American ambassador to Mexico, Dwight Morrow, who had put up the money for the Cuernavaca frescoes and who had recommended him for the work in North America and financed the trip, but for a well-known Communist sympathizer to cross the border required all the support of Diego's American admirers and collectors of his work.

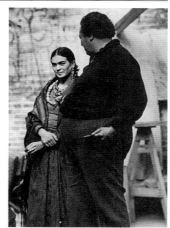

After a mixed reception on his arrival, Diego was hailed with enthusiasm following the success of *Allegory of California*, the mural he painted for the Luncheon Club at the San Francisco Stock Exchange. His own enthusiasm for the New World was unqualified and he was swept along by the dynamism of his new surroundings. Frida's reaction was more complex. In May 1931, she wrote to her childhood friend Isabel Campos: 'The city and the bay are staggering…. It was an excellent idea to come here because it's opened my eyes and I've seen a great number of new and wonderful things.' But

Opposite: The vitality and scale of Mexico's muralist revival had made a big impact on visitors attracted by the work of the *Tres Grandes* (Rivera, Orozco and Siqueiros), and news of Diego's commission for the Luncheon Club at San Francisco's Stock Exchange was met with enthusiasm in many quarters, though not by many American artists, who resented the choice of a foreigner. The success of *Allegory of California* (1930) silenced any opposition. In it, a young woman with brilliant blue eyes looms above a landscape that pays homage to the diversity of the region and its industry.

Above: Frida and Diego, photographed by Edward Weston in 1930.

regarding the Americans themselves she commented: 'I don't much like the *gringos*. They're boring and they all have faces like unbaked rolls.'

Frida felt lonely. Her husband was caught up in a whirlwind of work commitments and she herself had difficulty making friends with the women she met. Of course there was the language barrier too. Whether out of pride or bravado, she remained aloof, wearing her loneliness like a cloak, dressing in her traditional jewelry and clothes, and wrapping herself in long Mexican shawls. Edward Weston, who visited the couple in San Francisco following his separation from Tina Modotti, wrote in his journal: 'I photographed Diego again, his new wife Frida too…a little doll alongside Diego, but a doll in size only, for she is strong and quite beautiful, shows very little of her father's

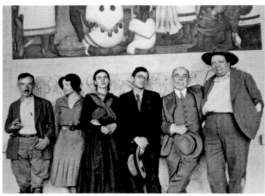

German blood. Dressed in native costume even to *huaraches* [sandals]. She causes much excitement on the streets of San Francisco. People stop in their tracks to look in wonder.'

Frida gave her own version of the disproportionate couple a year and a half after their marriage, in a kind of wedding portrait, entitled *Frida and Diego Rivera* (1931) and painted in the style of popular iconography. A recurrence of pain in her leg led her to seek help from Dr Leo Eloesser, a surgeon passionately interested in orthopaedics and specializing in problems relating to the ribcage. He became her friend and confidant and was to continue giving her medical advice over the years. By way of thanks and as a token of her friendship, Frida presented him with the *Portrait of Dr Leo Eloesser* (1931), and while she remained immobilized following an operation, she also painted a number of portraits of other friends.

Below, from left to right: Dr Leo Eloesser, Frances Flynn Paine, artistic advisor to the Rockefeller family, Frida, the muralist Jean Charlot, the French art critic Élie Faure, and Diego Rivera. The photograph was taken at the Cortés Palace, in Cuernavaca, in August 1931.

Opposite, top: Frida's interest in biology resurfaces in the allegorical portrait of horticulturalist Luther Burbank (1849–1926). A number of key motifs reappear in later works: the heavy clouds, the distorted scale and the hybrid figure – part human, part plant – growing from a skeleton.

Opposite, bottom: Frida painting the *Portrait of Mrs Jean Wight*, San Francisco, January 1931.

Mexican Interlude

In June 1931, the couple were recalled to Mexico, whose president, Pascual Ortíz Rubio, wanted Diego to finish painting the mural over the grand staircase in the Palacio Nacional. Frida was delighted to be back, surrounded by all that she loved: the gentle rhythms of life in Coyoacán, the tranquillity of her house, the chattering of her pets, the colours, sounds and smells of the place where she had grown up, the street life, the beauty of the indigenous people, the markets and the laughing children. She wrote to Dr Eloesser that Mexico was as chaotic as ever, in a terrible state; the one thing it did have, however, was the immense beauty of its landscape and of the indigenous people, she said. With the money he had earned in California Diego set about constructing a pair of houses in Mexico City's San Ángel quarter. The design was entrusted to Juan O'Gorman, a student of Le Corbusier, and he and Frida were each to have their own studio. Then Diego was recalled by new commitments, which included the first retrospective of his paintings at the new Museum of Modern Art (MoMA) in New York and a mural project at the Institute of Arts in Detroit. And so it was with a heavy heart that Frida took the boat back to New York with Diego in November 1931.

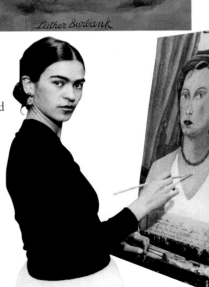

Luther Burbank

New York – 'An Enormous Chicken Coop'

Frida described New York as 'an enormous chicken coop that is dirty and uncomfortable'. It was the angry verdict of a woman living totally in the shadow of her husband. While Diego worked day and night in his MoMA studio preparing for the forthcoming exhibition, Frida had plenty of time to wander around the city and observe the effects of the Depression. She was scandalized by the rift between rich and poor, with the extravagant luxury of the wealthy on full display, while outside in the streets the homeless and unemployed queued at the doors of the soup kitchens. As usual she just spent hours looking and feeling bored, she wrote to Eloesser. Out of love for Diego, who took his role as ambassador of indigenous Mexican culture very seriously, she had given up everything that sustained her in her own daily life. Her only friend and confidante was Lucienne Bloch, Diego's assistant, whom she dragged with her to the shops and drugstores and cinemas. And in a world of monochrome greys she would always be dressed in one of her eye-catching costumes, so that children sometimes ran up to the two women in the street and asked 'Where's the circus?' Frida remained true to herself and her values, unafraid to cause a scene in hotels where Jews were prohibited from entering, free with her

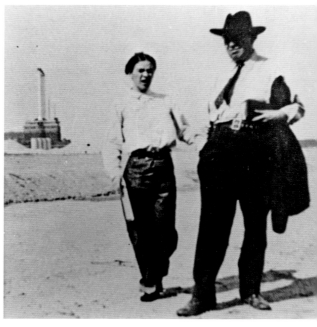

Below: Frida and Diego in 1932, visiting the Ford Motor Company in Detroit, Michigan, where Rivera painted his mural *Man and Machine* (1932–33). The mural covered the four sides of the central hall, known as the 'Rivera Hall', at the Detroit Institute of Arts.

Overleaf: View of the north wall, a total surface area of 434 m² (519 yd²), at the Detroit Institute of Arts.

language, which could be as colourful as her clothes.

Diego's retrospective, which had been initiated by the Rockefeller Foundation, opened on 22 December 1931 at the Museum of Modern Art on Fifth Avenue. It was ignored by the press and the critics, who questioned why a Mexican artist should receive sponsorship and commissions in a country in crisis, where a law had just been passed forbidding foreigners regular employment. There was support for the exhibition in intellectual circles, on the other hand, and so much interest among the general public that by the time the exhibition closed, at the end of January, the museum announced a record number of visitors.

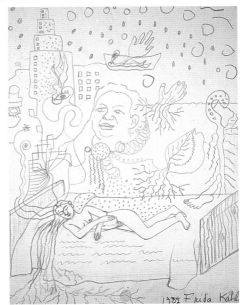

A bove: In *The Dream (Self-portrait Dreaming)* (1932) the artist's slender, rather androgynous body is plunged into a deep sleep. Each strand of her long hair is the vehicle for a thought that connects her with the world. The pencil drawing is gently erotic: a meditation on her new life, whose elements – industrial society, ocean crossing, continuing rootedness in her national soil – hover around Diego's giant, god-like head.

The Detroit Child

The couple took the train to Detroit in April 1932. The region was in the grip of a severe economic crisis and riddled with social tensions, but they nevertheless encountered more warmth there than in New York. The friendship and support of Dr William R. Valentiner and his colleague Edgar P. Richardson at the Institute of Arts, as well as the contact with immigrant Mexican workers, must have been a huge relief after their dealings with New York's snobs and society people. Diego was planning a mural entitled *Man and Machine* for the Detroit Institute of Arts, as excited as a child at the prospect of painting his machines and convinced that he had finally found the opportunity to 'paint the new race of the steel age'. With his sketchbook in his hand, he would wander endlessly back and forth across the factory floor at Ford, Chrysler and Edison, where work

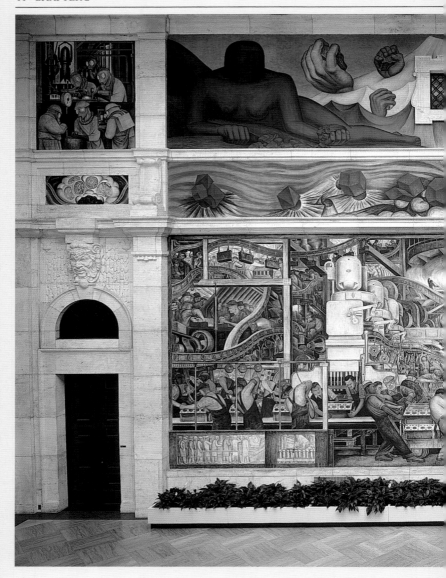

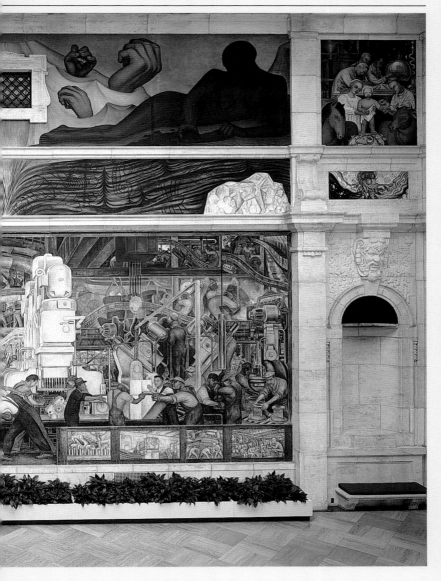

continued round the clock. Frida was absorbed by her own private dreams: she was pregnant again, but had not told Diego, and was hoping to keep the baby despite the medical advice. She had her doubts, however. She was afraid of losing Diego and afraid of complications, confessing to Dr Eloesser that she didn't know if it would be a good idea or not to have a child, given Diego's frequent trips away and her own reluctance to let him go off on his own while she stayed in Mexico. Once again her body made the decision for her and in her third month, during the night of 4 July 1932, she haemorrhaged and lost the baby. The spasms that shook her body as the ambulance men rushed her to the Henry Ford Hospital were spasms of utter despair.

The diagnosis was clear: congenital malformation (in common with all the Kahlo daughters), damage caused by the accident, including fractures to the pelvis, and abnormalities indicated by blood tests. In his grand mural for the Detroit Institute of Arts, Diego would immortalize the Detroit child as a germ of life enveloped in the bulb of a plant that sends its roots deep into the bowels of the fertile earth.

Ex-voto Paintings

Barely a fortnight later, a determined Frida was back on her feet and writing to Eloesser: '*Doctorcito querido....* I had so looked forward to having a little Dieguito that I cried a lot, but it's over, there is nothing else that can be done except to bear it....'

To help her start enjoying life again and encourage her to express herself, Diego – like her father after the accident – brought her painting equipment and books

Opposite: *Henry Ford Hospital (The Flying Bed)* (1932) was inspired by Mexican ex-voto paintings and was Frida's first work on metal, the start of a series of self-portraits whose subject matter is both bloody and terrifying. Frida lies on an iron bed, naked and bathing in a pool of blood. Her belly is still distended from the pregnancy.

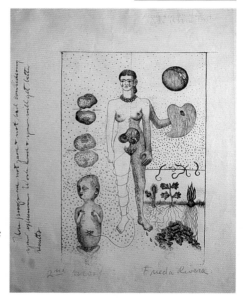

Above: In her first lithograph, *Frida and the Abortion (The Abortion)* (1932), there are spermatozoa floating in the air, beneath a weeping moon.

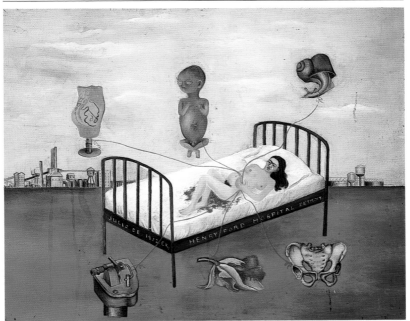

on medicine and anatomy, from which she reproduced the details of a male foetus in *Henry Ford Hospital (The Flying Bed)* (1932), her first painting on metal, and the lithograph *Frida and the Abortion (The Abortion)* (1932). Years later, in 1941, Dr Eloesser gave her a foetus preserved in a jar of formalin and she kept it in her room at Coyoacán, surrounded by her collection of dolls. She painted and drew continually, telling her story through her work, drawing on her intuition, finding ways to survive. Diego was full of admiration: 'Frida began working on a series of masterpieces that were unprecedented in the history of art – paintings glorifying the feminine qualities of endurance, truth, reality, cruelty and suffering. No woman had ever put so much poetic anguish on canvas as Frida, in Detroit and at this time' – homage, itself 'unprecedented in the history of art', paid by one great artist to another, and by a husband to his wife.

Both these works have echoes of Schopenhauer, whose philosophy Frida absorbed from her father. Like her father, Frida was interested in natural sciences, and in anatomy and physiology, and enjoyed examining things in minute detail. When she accompanied him on his various trips as a child, she would come home with a collection of bits and pieces – pebbles, stones, flowers, insects – which she would then study under the microscope or in a biology book.

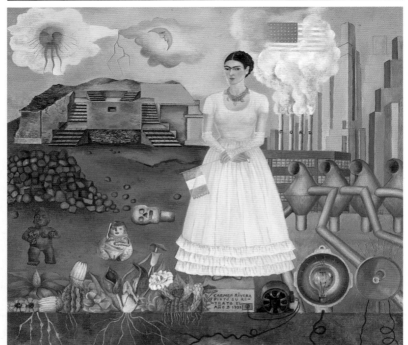

Two other paintings date from this time: *Detroit Window* (1932) and *Self-portrait on the Borderline between Mexico and the United States* (1932). Frida had invented a system of aluminium tubes that ran from floor to ceiling with a sliding support that could be adjusted depending on whether she was able to paint standing or sitting. Using the materials and the format of Mexican *retablos*, she painted on small metal plates that were first coated to ensure that the pigments adhered, covering the panels from left to right on a diagonal and finishing each section before she moved on to the next. Frida was the first artist to have rediscovered the ex-voto, with its particular format, themes and style, and to have adopted the violence of this popular form of expression. According to the German writer Paul Westheim, who studied the links between Frida Kahlo's painting and the ex-voto: 'What Frida Kahlo retains of the

Above: In *Self-portrait on the Borderline between Mexico and the United States* (1932), Frida stands with her arms crossed, conventionally dressed and holding the Mexican flag in one hand. Her expression is thoughtful and rather distant, reflecting her estrangement from ancient Central American civilization but also from a society where the machine is as important as water and air and sunlight.

popular spirit of the ex-voto, in addition to that vital affirmation, is the sincerity, the childish character of the forms and the expression of a truth told in such a way that it appears to contain a lie, since there are no limits separating the real, natural, objective world and the world of the imagination, the world of the unreal and the symbolic.' He quotes Ida Rodríguez Pampolini: 'In the *retablo*, the problem is always personal; there is invariably a single location: the self linked with a concrete event and its union with another world, that of miracle.' The saviour in popular ex-votos is represented as Christ or the Virgin or one of the saints; in Frida's paintings these figures are replaced by symbolic objects that float apparently weightlessly, as in *Henry Ford Hospital (The Flying Bed)*, or by her own choice of saviour, Marx for example in *Marxism Will Give Health to the Sick* (1954), or Dr Juan Farill in *Self-portrait with the Portrait of Dr Farill* (1951). The concentrated drama of the scene – often with the title of the picture inscribed above on a banderole – reflects a level of violence so direct as to be almost unbearable, as in *My Birth* (1932) or *A Few Little Pricks* (1935), the inspiration for which came from a newspaper report.

My Birth

Frida longed to return to Mexico, and in September she received a telegram that brutally reinforced these feelings. Her mother, Matilde Calderón, was in the final stages of breast cancer, and the message announced an alarming deterioration in her mother's condition. Accompanied by Lucienne Bloch, Frida made the long journey home by train. Her mother died a week later, on 15 September 1932, and Frida devoted herself exclusively to her family in the weeks that followed. One of her father's most beautiful portraits is the photograph

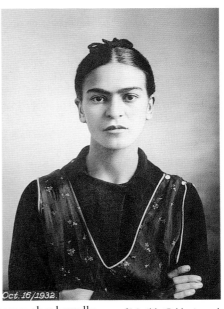

Below: This photo of Frida was one of her father's last portraits. It was his wife who had encouraged him to become a photographer and after her death Guillermo Kahlo abandoned his camera. Dated 16 October 1932, the photograph was taken exactly a month and a day after the death

of Matilde Calderón and shows Frida wearing a sleeveless blouse over her austere black dress, with her hair pulled back off her face. She had just lost not only her mother but also her baby, and all the light seems to have gone out of her eyes.

he took of her, prior to her return to Detroit, in which he captures the full measure of the artist's sadness. Back in the United States, Frida finished the painting she had begun before leaving. Entitled *My Birth*, it represents Matilde giving birth to Frida, but also Frida giving birth to herself, following the double loss of first her child and then her mother.

Man at the Crossroads

The cold weather arrived, and with it a coldness of a different sort. The opening of the Detroit murals, in March 1933, had already provoked a storm of protest, and America now saw the start of an anti-Rivera campaign fuelled by conformist and puritan attitudes. The American adventure, which had begun as an idyll in San Francisco in 1930, was to end in scandal and humiliation in New York at the close of 1933. The previous year, Diego had been asked if he would like to decorate the foyer of the brand-new Radio City building in the prestigious Rockefeller Center, in the heart of Manhattan. His preparatory drawings for *Man at the Crossroads Facing the Choice of a Better Future with Hope and Enthusiasm* had met with the approval of John D. Rockefeller and the muralist had set to work eagerly. He saw this as his opportunity to write a page of universal history, in a New York that welcomed him with open arms and was only too ready to reach into its pocket while he busied himself on his scaffold. On one side, he showed the United States – Wall Street businessmen, protesters, people out of work – and war; on the other, a utopian and Marxist vision of a world where workers, peasants, soldiers, teachers and mothers unite to construct a better future. Carried away by his

ROCKEFELLERS BAN LENIN IN RCA MURAL AND DISMISS RIVERA

COLORS ALSO NOT LIKED

Brilliance and Inclusion of Russian as a Symbol Were Held Likely to Offend.

Above and opposite: Reports on the Rockefeller Affair in *The New York Times* of 10 May 1933 and 16 February 1934.

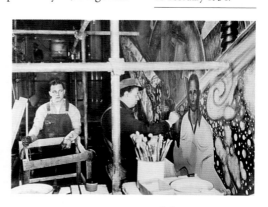

Above: Diego Rivera and Hugh Curry Jr working on the fresco *Man at the Crossroads* at the Rockefeller Center, New York, 1933.

subject and three quarters of the way through the project, he took a unilateral decision to substitute a trade unionist's face with Lenin's.

Rivera painted scenes of Communist activism while John D. Rockefeller paid the bill, according to the headline in *The New York World Telegram*. Rockefeller demanded that Diego replace Lenin's with an anonymous

RIVERA RCA MURAL IS CUT FROM WALL

Rockefeller Center Destroys Lenin Painting at Night and Replasters Space.

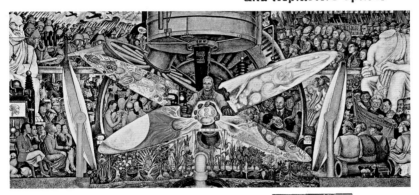

face. Bertram Wolfe, Diego's future biographer, suggested that he use Abraham Lincoln's. Diego refused, and the two sides engaged in a battle over

'VANDALISM,' SAYS ARTIST

ownership – the question being whether the mural (and with it the wall) was the property of the artist or whether it remained part of the real estate. The Rockefellers won the case and one May morning Diego was asked to gather up his brushes, come down from his scaffold and accept a cheque adjusted to reflect the unfinished state of the work. The murals were covered and nine months later scraped off.

This was war, and was widely commented on by the press. 'The Assassination of Art' ran the headline in *El Universal*. However, in the suffocating sameness of Frida's everyday life it was also a breath of fresh air. The couple exchanged their suite at the Barbizon Plaza for a two-room

apartment minus the doorman, and kept open house for artists and friends alike. And Frida resumed her true stature. She was another La Pasionaria, as splendid in her finery as she was virulent in her speech; she petitioned, campaigned, mobilized, marched, like some Mexican goddess of justice, while Diego worked tirelessly to find another site where he could reconstruct the 'Rockefeller mural' detail for detail with the money received from his previous backer. He found an initial outlet for his frustration in the revolutionary *Portrait of America* in twenty-three mobile panels for Bertram Wolfe's New Workers' School, but only really satisfied his thirst for reparation at home in Mexico, on the walls of the Palacio de Bellas Artes.

My Dress Hangs There

Frida painted just one picture during this period: *My Dress Hangs There* (1933), where her Tehuana costume hangs from a ribbon strung across a landscape symbolizing America's false promises. 'My dress hangs there,' she is saying and, by extension, 'My heart is here.' It is 'here', her Mexico, that lasts, while the United States, where she had spent almost four years, remains for Frida a 'there'. She was experiencing that profound form of melancholy which, in her father's language, is known as *Heimweh*: she was homesick. It was a source of conflict between her and Diego: she wanted to go home and Diego wanted to stay, persuaded that he could only fulfil his true artistic potential in the land of the machine, the land of industry, the land of tomorrow. But Diego was tired and humiliated. He had exhausted the last few dollars from the Rockefeller payment in the production of two small panels for the HQ of the New York Trotskyites and his commission for the Chicago Fair had been withdrawn.

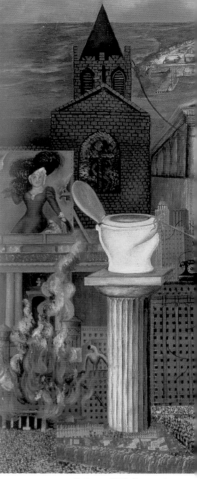

Above: Frida began *My Dress Hangs There* in New York, while Diego was involved with the Rockefeller Affair. She finished it, as a collage, in Mexico.

This sardonic vision of New York during the Depression serves as a kind of manifesto, 'signed' with one of Frida's Tehuana dresses, which hangs in the centre of the picture. During her earlier visits to America, Frida had experienced its appeal as a powerful and dynamic nation, but all that is subverted here by the image of a lavatory perched on top of a column and linked by a ribbon to a trophy sitting on top of another column. A crowd of have-nots demonstrate alongside a military parade. A dollar bill forms the window to Trinity Church. A fashionable blonde (Mae West) parades herself on a hoarding while down below buildings are consumed by fire. The illusions of a world of progress end up in the bin. The artist's dress hangs there, empty. The boat is leaving the harbour. She is dreaming of somewhere else – Mexico.

He decided to take the boat home and, on 20 December 1933, they sailed for Veracruz via Havana on the *Oriente*. 'We got together a group, put the money together, and bought tickets for them. Took them bodily to the boat and saw that they left,' said Louise Nevelson, Diego's assistant – and one of the first women to darken a conjugal sky that would soon be rent by storms of jealousy.

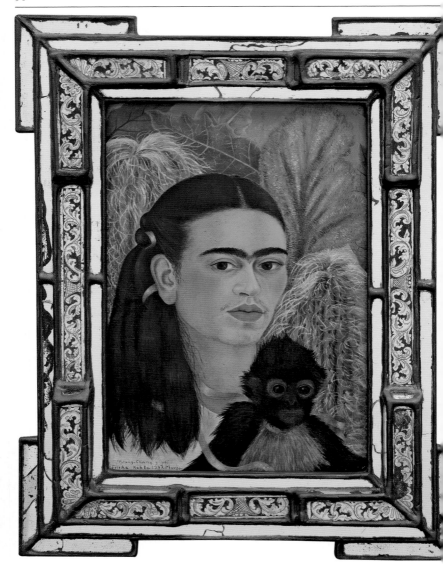

'There is no art more exclusively feminine, in the sense that, in order to be as seductive as possible it is only too willing to play alternately at being absolutely pure and absolutely pernicious. The art of Frida Kahlo is a ribbon around a bomb.'

André Breton, 'Mexique' catalogue, 1939

CHAPTER 3

SUCCESS AND SUFFERING

Opposite: The self-portrait *Fulang-Chang and I* (1937) exudes sensuality, with Frida Kahlo at the height of her beauty.

Right: Frida greeting the exiled Leon Trotsky and his wife, Natalia Sedova, on 9 January 1937, in Tampico.

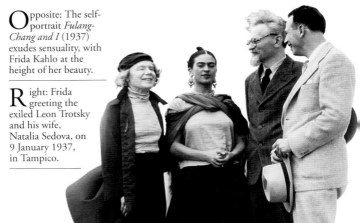

The Pair of Houses

The couple returned to Mexico, where they moved into the pair of houses designed for them by the muralist and architect Juan O'Gorman, a former pupil of Le Corbusier, in Mexico City's fashionable San Ángel district. The houses consisted of two functional cubes built of low-grade materials that made a 'social' statement through their total contrast with the neighbouring buildings, and were painted in Mexican colours: sky blue for Frida and blood red for Diego. A hedge of Organ Pipe cactus served as a boundary and a flight of steps with no handrail connected the two houses at mid-height – like a symbol of the relationship itself. A flight of stairs without a handrail, suspended in mid-air, for use by a woman who concealed a severe disability beneath her voluminous skirts: here was fuel for thought following the initial impact of the design, an interesting dialectic between dependence and liberty, innocent sadism and umbilical connectedness.

The houses soon became the Mecca of the international intelligentsia in whose bohemian atmosphere writers, painters, photographers, musicians, actors and militants came and went, along with domestic pets – spider monkeys, fawn, parrots and Itzcuintli dogs – and the lovers of the moment, male and female. But one lover too many, one too close, and Frida would be packing her bags.

A Few Little Pricks

There are no paintings from 1934, a year that brought further medical trauma and an emotional experience that wounded Frida deeply. She had to return to hospital on three separate occasions – for appendicitis, for another abortion, carried out by Dr Zollinger, again in her third month of pregnancy, and for an operation on her right foot. Frida's comment to Eloesser is sadly premonitory: 'My foot continues to be bad but it can't be helped and one day I am going to decide that they should cut it off so that it won't annoy me anymore.' Frida's favourite (younger) sister Cristina, whose husband had abandoned

Above: On their return from Detroit, in late 1933, Diego and Frida moved into the pair of houses in San Ángel, a modernist space arranged to reflect their personal tastes and creative aspirations. Diego's studio, like the backgrounds of his numerous portraits, was stuffed with favourite objects, which became the tools of his trade. Today the building is used as an exhibition centre and much of its original atmosphere has been lost.

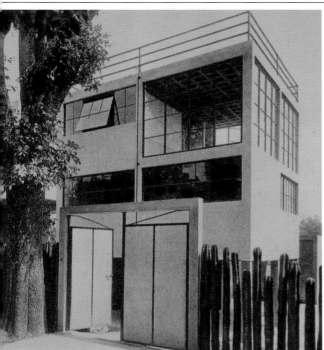

'All the furniture was modern: tables, chairs, sofas made of polished steel tubes, seats and cushions covered in an elegant lime-coloured leather. All of it contrasting with the red bricks of the ceiling, the white walls, the yellow parquet floor, the reed mats and Diego Rivera's brightly coloured paintings....'

Guadalupe Rivera,
Rivera's daughter

Below: Diego Rivera's *Mexico Today and Tomorrow* (1934–35). Diego frequently painted his lovers in his frescoes. In the mural for the Chapingo Chapel, Frida appears alongside Lupe Marín, to whom he was married at the time, while Frida's sister Cristina is in the foreground of *Mexico Today and Tomorrow*.

her and her two children, kept the invalid company during her convalescence. Diego, meanwhile, was furious about being forced to return to Mexico and took his revenge for his New York humiliation by painting John D. Rockefeller – in a second-floor mural for the Palacio de Bellas Artes – surrounded by prostitutes, in a scene of debauchery where a giant propeller stirs up syphilis bacteria. Since Frida was still indisposed, he fell into the arms of his sister-in-law, whom he had already represented as a voluptuous sex symbol in a mural for the Ministry of Public Health.

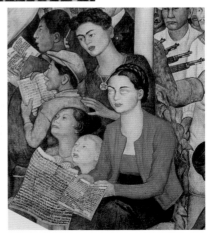

At the beginning of 1935, Frida left San Ángel and moved into a small flat in Avenida Insurgentes, in the centre of Mexico City, where she painted *A Few Little Pricks* (1935). The painting was inspired by a news story and shows a dead woman whose naked body is riddled with knife wounds. Her blood splashes over the bed and floor and right on to the frame of the picture, while her killer – whose features are not dissimilar to Diego's – stands by holding the knife, with his hat at a jaunty angle, coolly considering the spectator. And the woman who gazes out at us from the *Self-portrait* of the same year is quite a different Frida. Her hair is short and curly, her features are coarser, and both illusions and finery seem to

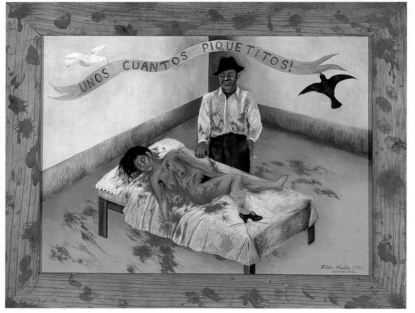

have been thrown aside in the same abrupt gesture. That union of body and soul as powerful as a bond of blood, a union that Frida assumed nothing would ever break, was just such an illusion. In a letter to Eloesser, she says: 'Now we can no longer do what we said we would do, destroy

Top: Frida's lover, the sculptor Isamu Noguchi, photographed by Edward Weston in 1935.

all of humanity and let only Diego, you, and me remain – since now Diego would no longer be happy.'

She found some solace with the handsome Japanese sculptor Isamu Noguchi and, while Diego immortalized his extended vision of the family by representing the two sisters together with Cristina's children in the *Mexico Today and Tomorrow* mural at the Palacio Nacional, Frida left for New York, and a change of scene. She was accompanied by two friends, the writer Anita Brenner and Mary Schapiro, who had recently separated from her husband. Long conversations with Bertram and Ella Wolfe, friends of the Riveras, and with Lucienne Bloch no doubt helped her to regain some peace of mind, and on 23 July 1935 Frida wrote a brave letter to Diego. Swallowing her pride, she held out for what really mattered: '…these flings with the first bit of skirt, with your English…teachers and your gipsy models, your "willing" assistants, your students passionate about "the art of painting", your "ministers plenipotentiary from faraway places", are just passing affairs, and when it comes down to it you and I love each other to distraction, and even if we have to put up with endless outbursts from one another, door banging, furious insults and phone calls from the other side of the world, we will always love each other.'

Frida returned to San Ángel, but beneath the apparent happiness a deep anxiety had set in, and it was at around this time that she began to use alcohol as a prop. 'I drank to drown my pain, but the damned pain learned how to swim!' she would later write to Ella Wolfe. *My Grandparents, My Parents and I* (1936) seems to have been a way of reforging the bonds that connected her to life, of reconnecting with the first bonds of love and warding off her terrible fear of abandonment. It shows Frida as a little girl standing naked in the middle

Opposite: In *A Few Little Pricks* (1935), Frida used a particularly morbid newspaper report to distance herself from the pain of her recent betrayal by Diego and her sister Cristina. The victim has her sister's features, and the man with the knife is made to look like Diego, while Frida imagined that she herself had committed the murder.

Above: In this photograph, taken by Lucienne Bloch, Frida points firmly to a bottle of Cinzano, as if to indicate a different answer to her problems.

of the patio at the Casa Azul, holding the ribbon that unites her with her parents as young newlyweds behind her – her mother pregnant beneath her white dress – and her two sets of grandparents, placed like guardian angels on the clouds to either side of the tiny figure of the child.

The 4th International

The Casa Azul was where Frida spent her early years – before Diego whisked her off to bigger and better things. And it was the Casa Azul that provided the stage for a brief moment in history, becoming a fortress and a sanctuary for the great Russian revolutionary Leon Trotsky during two years of exile.

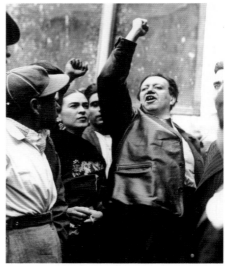

Whatever their marital conflicts, there was one area where Frida and Diego were never divided – their commitment to the same political vision. When the Spanish Civil War broke out, on 17 July 1936, Frida helped to found the Foreign Committee whose job was to collect funds abroad for the Republican cause and, sharing her husband's admiration for Trotsky, she joined the 4th International, which Trotsky founded to mark his break from Stalin. A telegram from Anita Brenner informed the couple of the imminent arrival of Trotsky and his wife, Natalia Sedova, following their expulsion from Norway. Diego requested that President Lázaro Cárdenas grant them right of asylum in his own name and it was Frida who went to meet the Trotskys off the boat at Tampico, on 9 January 1937. She also put them up with her servants in the family home, now deserted by her father, who was living with Adriana, and by Cristina, whom Diego had set up in her own home a short distance away. Trotsky did not speak Spanish, so it was Frida too who acted as a guide and interpreter.

Above: Frida and Diego at an anti-fascist demonstration in Mexico City, organized by the Workers' Party, on 23 November 1936. The couple were united by both their artistic and their political commitment.

Opposite: Frida escorting the Trotskys from the tanker *Ruth* on to Mexican soil, where they would be given asylum until the leader's assassination by Ramón Mercader in 1940. Diego was hospitalized at the time due to problems with his eyes and frustrated that he was unable to go to Tampico to greet the exiles. Frida went in his place.

The Communist theorist, author of *The Permanent Revolution*, though not particularly young any more, was still an impressive man, and was quick to respond to the charms of his beautiful hostess, who had not quite turned thirty. The two couples spent a great deal of time together, sharing their meals, going on picnics and touring the area around Mexico City. Frida and Trotsky spoke to each other in English, a language that Natalia did not understand, and in between their meetings he would lend her books with little billets-doux slipped between the pages. As a present for Trotsky's birthday on 7 November – which was also the anniversary of the Russian Revolution – Frida gave him her seductive *Self-portrait Dedicated to Leon Trotsky* (1937). It was her way of taking leave of an affair too difficult to pursue given her lover's famous reputation, Diego's murderously jealous tendencies and the threat of the Soviet secret police, the NKVD.

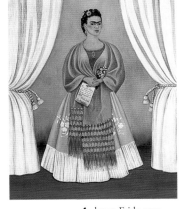

Above: Frida gave this *Self-portrait* (1937) to Trotsky for his birthday and to mark the end of their affair. He left it at the Casa Azul.

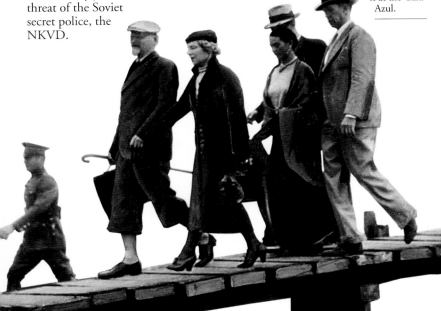

A Prolific Period

Frida was in full possession of her powers of seduction – her affair with the great revolutionary leader had confirmed as much to her – and at the height of her beauty, which we see her affirming openly in her self-portraits *Fulang-Chang and I* (1937) and *Self-portrait with Itzcuintli Dog* (1938) and in *Memory of the Open Wound* (1938), a provocative and sensual reminiscence of the pain of betrayal. Her painting too was becoming stronger, increasingly accomplished, as she worked alongside Diego. These years saw the production of a series of works – *My Nurse and I* (1937), *Four Inhabitants of Mexico* (1938) and *What the Water Gave Me* (1938) – that are introspections or analyses of her relationship with the world in which she boldly exposes the full complexity of her mental and emotional processes. She had never produced so much since the start of her marriage as in the years 1937 and 1938. 'As you can see, I have been painting,' she wrote to Ella Wolfe in the spring of 1938, 'which is quite something, given that up until now I have spent my life loving Diego and being a good for nothing as regards work; but now I'm continuing to love Diego and in addition I've started to paint monkeys seriously.' Her work would no longer draw exclusively from the source of her being, but from the whole storehouse of images recorded by those deep dark eyes set beneath brows like 'blackbird wings': images drawn from her father's portraits, from pre-Columbian statuary, the ex-votos of the last century, the prints of José Guadalupe Posada, Goya's macabre scenes and Brueghel's

B elow: *Little Girl with a Death Mask* (1938) is inspired by the naïve style of popular Mexican art. The little girl wears a white death mask and holds a *tagete* (sunflower): sunflowers are used during the Day of the Dead, on 2 November, to light the path for the souls of the dead as they make their way back to their ancestors. Next to her is a jaguar mask in papier mâché, another ritual accompaniment at this annual festival.

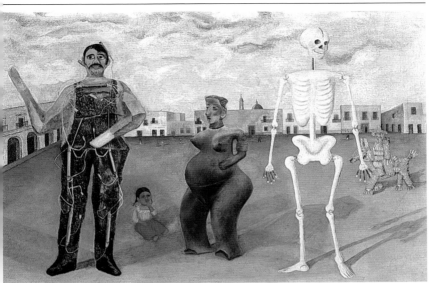

folk dances, the visions of Hieronymus Bosch and of René Magritte – a whole artistic education to which life events brought their own material for expression. What Frida was interpreting was herself: 'I paint self-portraits because…I am the person I know best.'

'A Ribbon Around a Bomb'

At the beginning of 1938, Diego encouraged Frida to show some of her work in a collective exhibition being held at the university gallery and it was through him that she sold four paintings to the celebrated American actor Edward G. Robinson, who was in Mexico at the time and eager to meet the muralist. This was Frida's first big sale, and the start of her financial and artistic independence. Further confirmation of her growing reputation came in April of the same year from André Breton, founder of the Surrealist movement. Breton had been sent by the Quai d'Orsay to give a series of lectures in Mexico and he was literally fascinated by Frida and her work: 'My surprise and joy were unbounded when I discovered, on my arrival in Mexico, that her work had

Above: In *Four Inhabitants of Mexico* (1938), a little girl sitting on the ground in an empty square represents the artist's persistent inquiry into her origins. In the foreground, we see the familiar figures of Mexican folklore, which Frida frequently introduces into her paintings by way of an answer: a pre-Columbian terracotta statuette, the white skeleton that served as a model for her drawings, and a handless workman supported by electrical wires, indicating her interest in science and technology.

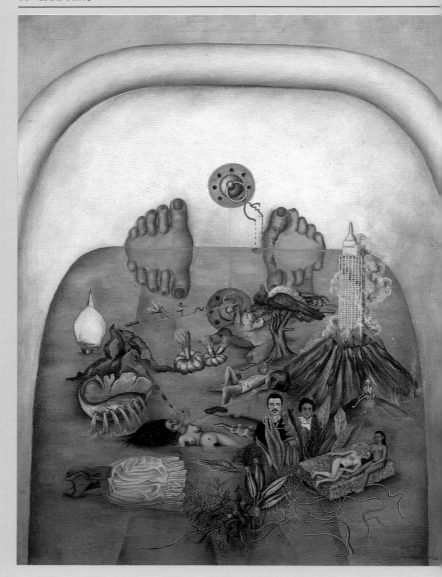

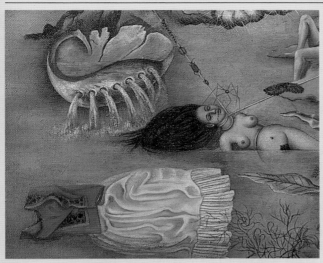

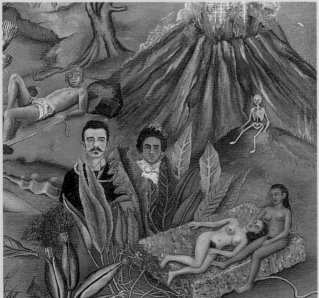

*W*hat the Water Gave Me (1938) is without doubt Frida's most surrealistic work – the reverie of the solitary bather, with various elements of her life surfacing from the watery world that floats above her submerged legs. Blood trickles from the plughole at the end of the bath and Frida's two feet, reflected in the mirror of the water, rest against the white enamel, the blood-red toenails carefully painted – a detail that makes the deformity of the right foot and its open wound seem even more shocking. A tiny version of her Tehuana costume floats in the water, next to a naked Ophelia, Frida herself, strangled by a rope that connects her on one side to a rock and on the other to the wrist of a young Christ-like figure lying against the side of a volcano, from which a phallic-looking Empire State Building emerges. Along the rope itself a nightmare sequence of funambulists process, including spiders, insects and snakes. From this universe of lianas and aquatic plants, the reassuring figures of Frida's parents emerge, in wedding clothes, while on a big bed, two women prefigure the painting *Two Nudes in the Forest* (1939).

blossomed forth, in her latest paintings, into pure surreality, despite the fact that it had been conceived without any prior knowledge whatsoever of the ideas motivating the activities of my friends and myself.' Diego and Frida invited Breton and his wife to live with them while they were in Mexico and the two couples spent a great deal of time together, and also with the Trotskys. They went to Michoacán together, and Diego, Breton and Trotsky co-wrote the manifesto *For an Independent Revolutionary Art*, while Frida and Jacqueline Breton, the beautiful heroine of *Mad Love*, also a painter, preferred practising their art and playing games of consequences to the endless theorizing of their respective partners.

The gallery owner Julien Levy had heard about Frida's work and offered to hold her first solo exhibition in New York, at his gallery on East 57th Street, in November of that year. Breton wrote an article for the catalogue and invited her to come to Paris following her trip to New York, with the promise of an exhibition there too. Describing her as 'adorned like a fairy-tale princess, with magic spells at her fingertips', he wrote: 'There is no art more exclusively feminine, in the sense that, in order to be as seductive as possible it is only too willing to play alternately at being absolutely pure and absolutely pernicious. The art of Frida Kahlo is a ribbon around a bomb.'

Frida showed twenty-five works in New York, and – despite the Depression – half of them sold. This was success. Diego had drawn up the list of invites for the private view (even including the Rockefellers), and the event caused a stir, as did Frida herself, gorgeous as ever in her Mexican costume. The critics were enthusiastic and people

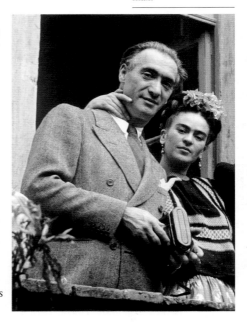

Below: After their tumultuous affair, the Hungarian-born American photographer Nickolas Muray remained a close and loyal friend to Frida. Frida's gentle expression and her intimate gesture give a sense of this in this photograph, taken by Muray at Coyoacán in 1939. Muray was generous to her with his money, and Frida confided in him and wrote to him frequently, describing him as a Wilhelm Kahlo of German-Hungarian origins, a photographer by trade, a generous, intelligent and refined man.

AL PUBLICO
DE LA AMERICA LATINA

y del mundo entero, principalmente a los escritores, artistas y hombres de ciencia, hacemos la siguiente declaración:

Summer 1938 in Mexico City saw the formation of a curious trio in the garden at the Casa Azul: André Breton, Diego Rivera and Leon Trotsky (below). Three men who were completely different both mentally and physically, but united by a shared belief in Communism and

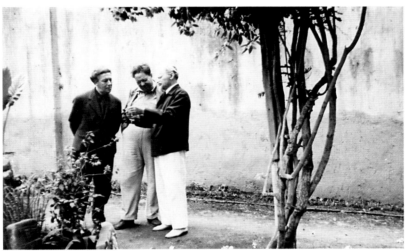

began to commission new works. Frida painted *Self-portrait with Monkey* (1938) for the industrialist Conger Goodyear and *The Suicide of Dorothy Hale* (1938–39) for Clare Boothe Luce, editor of the fashion magazine *Vanity Fair*. She was caught up in a whirl of new-found stardom and, safe from Diego's prying eyes (and his pistol), not short of lovers, including Julien Levy and, more importantly, the great Hungarian-born portrait photographer Nickolas Muray, who helped her prepare her exhibition, photographed her works and regularly gave her money. 'My Nick,' she writes, 'you are the sweetest person I have ever known. But listen darling, I don't really need that money now. I got some from

who coordinated their talents to produce – after lengthy theorizing and verbal jousting – a manifesto (top) for the whole world: *For an Independent Revolutionary Art*. It was following his trip to Mexico that André Breton brought Frida and her work over to Paris and set about trying to enlist her as an exponent of Surrealism.

Mexico, and I am a real rich bitch, you know?'

Beyond Surrealism

'Don't be silly. I don't want you for my sake to lose the opportunity to go to Paris. TAKE FROM LIFE ALL WHICH SHE GIVES YOU, WHATEVER IT MAY BE, PROVIDED IT IS INTERESTING AND CAN GIVE YOU SOME PLEASURE.' This was Diego's response to Frida's doubts about the French trip, and her anxiety about leaving him for so long and going so far. It was perhaps his way too of ensuring a bit of freedom for himself. So, in January 1939, Frida took the boat to France, crossing the Atlantic to a Europe already darkened by the wings of Fascism.

She went to stay with the Bretons at 42, rue Fontaine, in Paris's 9th arrondissement, the headquarters of the Surrealist and Trotskyite movements. Conditions there were cramped and Frida rapidly became disillusioned with what she regarded as Breton's complete lack of professionalism. His plans for mounting the exhibition were completely nebulous. 'Until I came the paintings were still in the customs house, because the s. of a b. of Breton didn't take the trouble to get them out…. The gallery was not arranged for the exhibit *at all*…. So I had to wait days and days just like an idiot till I met Marcel Duchamp (a marvelous painter) who is the only one who has his feet on the earth, among all this bunch of coocoo lunatic sons of bitches of the surrealists,' she writes to Nickolas Muray on 16 February 1939. She was in the American Hospital at the time, suffering from a violent dose of colibacillosis which she attributed to

Above: Marcel Duchamp in his Paris studio.

Below: André Breton's handwritten preface to the catalogue for the 'Mexique' exhibition at the Pierre Colle gallery, with the catalogue cover (right).

her hosts' dubious standards of hygiene. Duchamp's American girlfriend, Mary Reynolds, put her up in her Montparnasse apartment and the painter went to great lengths to sort things out for her; he was the only one she had any time for. '[Duchamp] immediately got my paintings out,' she writes, 'and tried to find a gallery. Finally there was a gallery called "Pierre Colle" which accepted the damn exibition [sic].... [The others] make me vomit. They are so damn "intelectual" [sic] and rotten that I can't stand them any more.'

The exhibition was entitled 'Mexique' and Frida was not really the focus of the show. Two of her pictures were withdrawn because they were regarded as too audacious for the Parisian public, and 'Now, Breton wants to

exhibit together with my paintings 14 portraits of the XIX century (Mexicans) about 32 photographs of Álvarez Bravo, and lots of popular objects which he bought on the markets of Mexico – *all this junk*, can you beat that?'

Overshadowed by the threat of war, the show was not a financial success either: the only painting that was sold was a brilliant little self-portrait, *The Frame* (1937–38), executed with the precision of a miniature, which was purchased by the Louvre. But the exhibition was a real *succès d'estime* and galvanized Paris's artistic community. It brought Frida into contact with Paul Éluard, and with Max Ernst, who fascinated her, though she found him icy. Yves Tanguy and Joan Miró expressed their enthusiasm for her work; Kandinsky was moved to tears

'My surprise and joy were unbounded when I discovered, on my arrival in Mexico, that her work had blossomed forth, in her latest paintings, into pure surreality, despite the fact that it had been conceived without any prior knowledge whatsoever of the ideas motivating the activities of my friends and myself. Since the beginning of the 19th century, Mexican painting has been more shielded from foreign influence than any other, more profoundly focused on its own resources, and at this present stage in its development, here at the other side of the world, I found the same line of questioning spontaneously emerging: what irrational laws do we obey, what subjective signs direct our actions at any given moment, what symbols, what myths are operating in this or that collection of objects, this or that web of events, what meaning should we accord to the mechanism of the eye that enables us to switch from the visual to the visionary?'

André Breton,
'Mexique' catalogue

by it, and Picasso gave her a set of earrings in the shape of a pair of hands as a token of his friendship, and acknowledged later to Diego: 'Neither Derain nor myself, nor you, are capable of painting a head like those of Frida Kahlo.' Summing up for the Wolfes on 17 March, Frida said: 'In sum I can say that it was a success, and taking into account the quality of the taffy (that is to say the crowd of congratulators) I believe that the thing went well enough.'

The event was also celebrated in the press. L.-P. Foucaud, writing for *La Flèche de Paris*, comments that each of the seventeen paintings shown was 'a door opening on to the infinite, the continuity of art' and that '[at] a time when artfulness and deception are fashionable, the integrity and the striking exactitude of Frida Kahlo de Rivera offer a welcome relief from all that ingenious brushwork'. The couturière Elsa Schiaparelli, meanwhile, was so taken with Frida's Mexican attire that she offered her clients a Madame Rivera dress.

Frida was too much of a free spirit to be carried away by these Parisian accolades or allow herself to be limited by the label 'Surrealist'. Her painting does much more than shock the spectator out of conventional middle-class attitudes: it is rooted in the world of the artist's imagination and the day-to-day life of her native Mexico and cannot be bent to fit a law laid down by Breton and his friends. 'I never paint dreams. I paint my own reality,' she acknowledged simply.

Diego's biographer, Bertram Wolfe, emphasizes this distinction: 'Though André Breton…told her she was a *surrealiste*, she did not attain her style by following the methods of that school…. Quite free, also, from the Freudian symbols and philosophy that obsess the official Surrealist painters, hers is a sort of "naïve" Surrealism, which she invented for herself…. While official

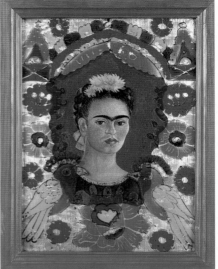

Above: On 19 March 1939, Frida showed seventeen paintings at Pierre Colle gallery in Paris. One was sold to the Louvre: the charming self-portrait *The Frame* (1937–38) which shows Frida with her hair braided, a green ribbon threaded through and a cluster of yellow flowers. She is surrounded by a border of flowers and birds in hot Mexican colours. The painting is housed today at the Musée National d'Art Moderne at the Centre Georges-Pompidou.

Surrealism concerns itself mostly with the stuff of dreams, nightmares, and neurotic symbols, in Madame Rivera's brand of it, wit and humour predominate' (quoted in *Vogue*, New York, October/November 1938).

Frida was intoxicated by the beauty of Paris, but weary of all the palaver, and on 25 March she left Le Havre in the company of two beautiful dolls she had bought for a song in a Parisian flea market.

Cutting Off the Braids

Frida stopped off in New York on her way back, only to find that her handsome Hungarian had fallen in love with another woman, shortly to become his wife. It was the prelude to an even more painful separation: returning home before the end of April, she discovered that Diego was again involved with her sister Cristina.

Trotsky had left the Casa Azul following a disagreement with Diego, who had resigned from the 4th International, and during the summer of 1939 Frida deserted the marital home and took refuge in the Casa Azul. On 1 September, Hitler invaded Poland and on the 3rd Britain and France declared war on Germany. In mid-October, Mexico's emblematic couple, Diego and Frida, filed for divorce by mutual consent at Coyoacán's county court. It was Diego who had taken the initiative: 'I loved her too much to want to cause her suffering, and to spare

Below: Photograph of Frida taken in Diego's studio at San Ángel. She was showing some of his watercolours to the American collector Helena Rubinstein with her friend Emmy Lou Packard. Her hair is pulled back from her face, oiled and braided with wool, Mexican fashion, and piled on top of her head, and she is wearing the earrings in the shape of a pair of hands which Pablo Picasso had given her during her stay in Paris. Her *rebozo* is skilfully draped around her shoulders and the embroidered corsage sits next to her skin. Frida herself was part of what collectors came to Mexico to see.

her further torments, I decided to separate from her.... We still loved each other. I simply wanted to be free to carry on with any woman who caught my fancy.' This was how he justified himself in his autobiography: it was not that his feelings had changed, but that he needed to cut the cord.

Frida completely lost her bearings, confiding her feelings of helplessness to Muray, who had kept up the friendship: 'Now I feel so rotten and lonely that it seems to me that nobody in the world has to suffer the way I do....' As always, her emotional state was mirrored by her physical condition and her back was now causing her so much pain that Dr Farill recommended absolute rest and encouraged her to wear a specially weighted garment to help stretch her spine. Frida was no longer interested in seeing the couple's erstwhile friends. She cut herself off and began drinking again. In December she received the announcement that their divorce had been granted.

A month later, Frida cut her hair – that long brown hair that Diego loved – and shed her Tehuana costume like a skin. In *Self-portrait with Cropped Hair* (1940), she appears with her scissors in her hand, dressed in a suit (her ex-husband's?), so enormous it swamps her, and sitting on a rush-seat chair in the middle of a floor strewn with strands of hair. Whether the scene represents

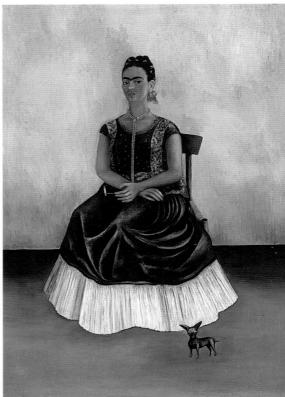

Above: *Self-portrait with Itzcuintli Dog* (1938) shows Frida sitting, her figure barely discernible beneath the dark dress, her arms limply folded in her lap and a chain in the form of a slipknot round her neck. Her eyes have a faraway look – the effect of the marijuana cigarette in her left hand. The black dog symbolizes the god Nahual, guide of doubting souls in Aztec mythology.

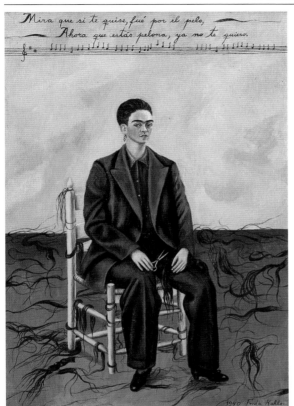

Mira que si te quise, fué por el pelo,
Ahora que estás pelona, ya no te quiero.

Left: In *Self-portrait with Cropped Hair* (1940), the viewer witnesses a scene unfolding in private. The dominant colours of the painting are dark and peaty, and the clouds in the background are so dense that not the slightest chink of blue sky is visible. Alone on her chair like a prisoner in her cell, the artist has taken her decision: she has cut her hair – and with it her ties to Diego. At the top of the picture, like the headline from some gory newspaper report, we read: 'If I loved you, it was because of your hair, you see. Now that you're bald, I don't love you any more.' Like the criminal with his knife in *A Few Little Pricks*, Frida looks at us provocatively, still holding the scissors in her hand, forcing us to witness her act of self-destruction. This is her way of avenging herself, her response to the card that Fate has dealt her; but surrounded by all those strands of dead hair, those remnants of her past, she may also be waiting for the dawn of a new life, ready to give her head a shake and feel it lighter now, freed of its shackles. Diego himself commented that it was during the period of their separation that Frida produced her best works.

female castration or reconquered liberty, or both, is unclear. More portraits were to follow as she gazed deeper and deeper into the mirror, representing herself, in her solitude, surrounded by domestic animals that express her dreams of renaissance, her erotic desires, and her martyrdom. Two self-portraits, in particular, dating from the year of her divorce use the imagery of Christian martyrdom, showing the artist wearing the crown of thorns around her neck, while *The Wounded Table*, painted in 1940, recalls the Last Supper, on the eve of Christ's Passion. In it we see Frida sitting magisterially behind a table from which blood is flowing, and on either side of her are a Judas figure

and a skeleton, her fawn and her nephews. She was haunted by thoughts of death, and in *The Dream* (1940) we see Death lying on the canopy of her bed, adopting an identical position to the sleeping woman. During the period of her separation from Diego, Frida also completed *The Suicide of Dorothy Hale*, which she painted in response to the commission she had received from Clare Boothe Luce in New York – perhaps as a way of channelling her own suicidal impulses. Dorothy Hale had thrown herself out of a window of the Hampshire House building and Frida's painting shows the stages of the young woman's fall, as if in slow motion, and her body lying on the ground, her blood dripping down over the frame. The painting is so strikingly realistic that when Clare Boothe Luce received it she was apparently tempted to tear it up.

In *The Two Fridas* (1939), the double so frequently tracked in the mirror came to stand beside Frida, as the other half of the couple. The two women hold hands, one dressed in European style, the other in Mexican clothes, a reminder of the artist's dual ancestry and the energy she drew from returning to her roots, as in *Two Nudes in the Forest* (1939), where a white woman lies with her head in the lap of an indigenous Mexican.

Frida also painted a series of still lifes with fruits and flowers, beginning in 1938 with *Fruits of the Earth*, *Pitahayas* and *Cactus Flowers*. These paintings are in the same tradition as the *bodegones* painted in the 19th century and used to decorate dining room walls, but their erotic forms suggest a highly personal set of stylistic references.

Frida worked frenziedly, selling her pictures through Julien Levy. Friends and patrons rallied round, bought pictures and sent money.

B elow: Frida working on *The Wounded Table* (1940), one of her largest paintings. Set on the ground, with the framing effect of the heavy red curtains, the picture looks particularly theatrical. Frida is typically facing herself, the white flounces of her skirt mirroring the white flounces of the painted figure. This work and *The Suicide of Dorothy Hale* (opposite) were both painted during the time of her separation from Diego and, although very different, they are linked by their preoccupation with death. *The Wounded Table* represents Frida surrounded by her Mexican apostles like Christ on the eve of that fateful Friday.

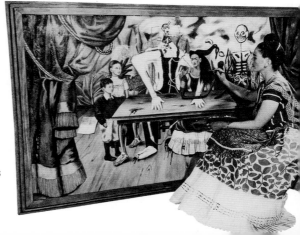

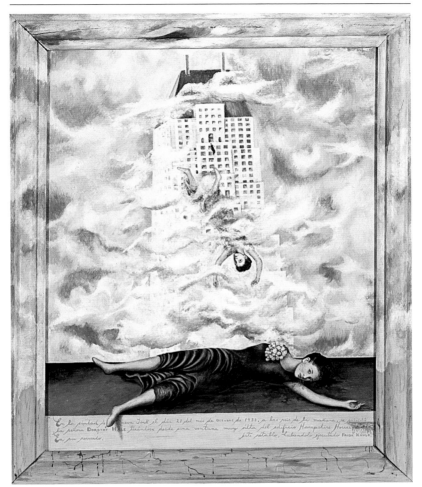

She declared to Muray (who remained generous) that she could now count on her own work alone.

Remarriage

Trotsky escaped an assassination attempt on 24 May 1940 and suspicion fell upon Diego, with whom he was known to have fallen out recently. It was only thanks to

Above: *The Suicide of Dorothy Hale* (1938–39) shows the death of a woman who calmly orchestrated her suicide after learning that the great love of her life would not marry her.

Death is just seen as part of life in Mexico, where papier mâché Judas figures and candy skulls are familiar, everyday objects, and Frida had attached a Judas (in the form of a skeleton) to the canopy of her bed. In *The Dream* (1940), the figure is lying in an identical position to that adopted by the sleeping woman, his head like hers resting on two pillows, powerfully evoking the theme of death and the maiden. While the leafy branches on the embroidered coverlet reach up to envelop Frida's sleeping figure, the Judas is wrapped in wires and explosives – suggesting that the whole thing is just a joke and that the firecrackers will go off, blowing him to bits, as on the Day of the Dead, but also that the life of the sleeper is in danger. We are reminded of Frida's words to Alejandro, fifteen years earlier, immediately after her accident: 'death is dancing around my bed all night long'. All the paintings from the period of Frida's separation from Diego are haunted by her obsession with death, if also accompanied by more mundane preoccupations.

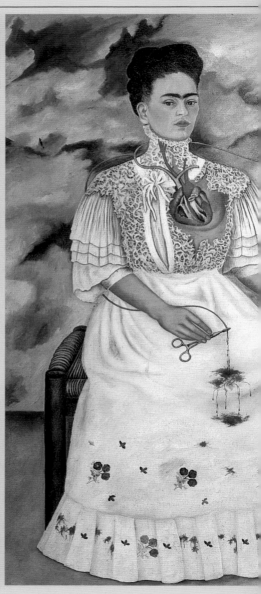

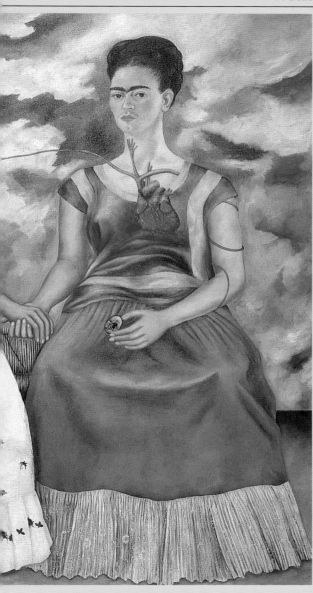

Frida painted herself beside her double in the monumental work *The Two Fridas*, dating from 1939, around the time that the final settlement of her divorce from Diego was announced. She is sitting very upright on a bench with a fixed look on her face as if to affirm the reality of her isolation – from whose (apparent) inevitability she draws consolation and strength. The left-hand Frida is wearing a white dress; the other a Tehuana skirt and blouse, Frida's favourite kind of outfit since her marriage to Diego. A gorged blood vessel connects a wounded and bleeding heart to the other intact heart. The sad Frida holds the hand of the brave Frida, as if to seal more firmly – in an act of complicity with herself – her triumph over her wounds, while enclosing her great Diego in a tiny amulet which she holds in her fingertips. Frida showed the painting the following year at the International Exhibition of Surrealism in the Galería de Arte Mexicano run by Inés Amor, and later at the retrospective 'Twenty Centuries of Mexican Art' organized by the Museo de Arte Moderno.

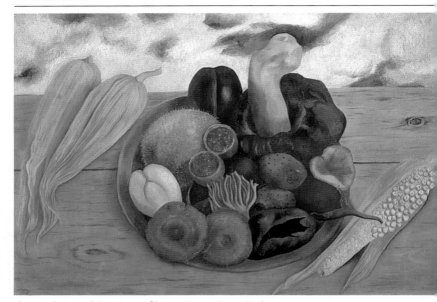

the tender machinations of his assistant Irene Bohus and of the actress Paulette Godard, whose hotel room overlooked the San Ángel studio, that the police dropped him from their investigations. Diego deemed it prudent, nevertheless, to leave Mexico and travel to San Francisco, where he had been promised a commission to paint a fresco for the Junior College library. As one of the artists involved in the Golden Gate International Exposition's 'Art in Action' project, he had been asked to paint the work on Treasure Island where the public would be free to watch. Stalin and Hitler had signed a treaty in 1939, and in response Diego set out to express pan-American unity and solidarity in what he described as the marriage of the artistic expression of the North and of the South on this continent, a bridge-building exercise, finally, with the northern states.

Diego was eager for reconciliation on another front too and, with Dr Eloesser's help, was trying to persuade Frida to come and join him. Three months later, Trotsky was shot dead by Ramón Mercader. Frida had known Mercader in Paris and it was now her turn to be arrested

Above: There is a clear sexual suggestiveness about the fruits and vegetables in *Fruits of the Earth* (1938). The two mushrooms in the foreground resemble breasts; the whitish fruit to the left is shaped like a vagina; the aubergine at the back of the dish suggests a pair of buttocks, and towering over the whole arrangement is a strange phallus-shaped mushroom. The seeds exposed in the red pulp of the cut fruit relate to Frida's personal system of symbols, and her preoccupation with the transformative potential in her body and her life.

and subjected to lengthy interrogations. She was finally cleared of any involvement, but was left deeply distressed by her experience and by Diego's departure. She fell ill and decided to take the plane to San Francisco.

At the beginning of September, Eloesser had her admitted to St Luke's Hospital for a programme of rest and detoxification. Frida recovered and in November left for New York to help Julien Levy prepare a new exhibition planned for 1941. Using Dr Eloesser as an intermediary, Diego bombarded her with marriage proposals. Frida finally said yes, but on two conditions: that she should be financially independent and that the couple would have no sexual intercourse. 'I was so happy to have Frida back that I assented to everything,' Diego said.

The couple remarried in San Francisco on 8 December 1940 (Diego's birthday), a year after they had divorced.

B elow: Frida, her face thinner and more drawn, photographed with Diego on 5 December 1940, three days before they remarried in San Francisco.

B ottom: Frida was a great letter writer. She wrote in a vigorous style and decorated her letters with little drawings and lipstick kisses. This is an extract from a letter to Emmy Lou Packard dated 24 October 1940.

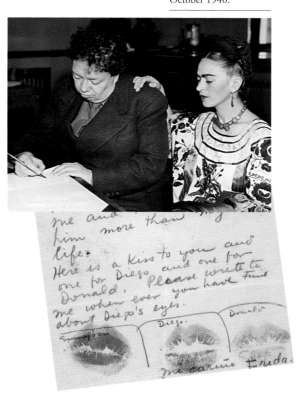

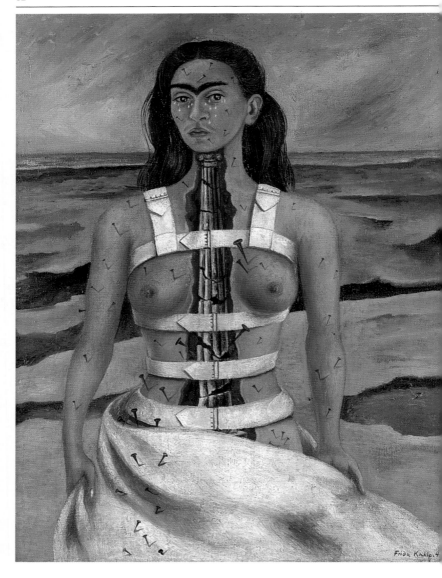

'I recommend her to you, not as a husband but as an enthusiastic admirer of her work, acid and tender, hard as steel and delicate and fine as a butterfly's wing, loveable as a beautiful smile, and profound and cruel as the bitterness of life.'

Diego Rivera to an American critic, 1938

CHAPTER 4
'LIFE IS THIS WAY'

Opposite: In *The Broken Column* (1944), Frida appears against the fissured earth of an empty volcanic landscape. She looks straight ahead of her, as if challenging the viewer to confront her suffering, and exposes her wounds like a martyr.

Right: Frida seen as a maternal figure by Diego, who portrays himself in the same image as a small boy.

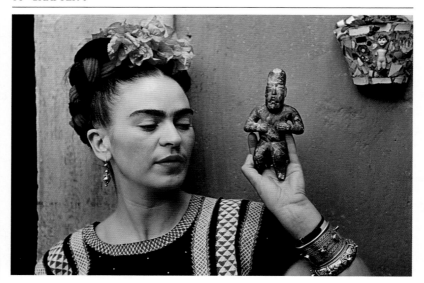

Harmony Restored

Peace had been restored and they each returned, independently, to Mexico and their shared life in a Casa Azul readapted for the purpose. Diego kept his studio-cum-bachelor-flat in San Ángel and Frida cared for him like a mother, resuming her life in the company of her double and her opposite. She describes her philosophy of marriage in a letter to Eloesser (18 July 1941): 'The remarriage functions well. A small quantity of quarrels – better mutual understanding and on my part, fewer investigations of the tedious kind, with respect to the other women, who frequently occupy a preponderant place in his heart. Thus you can understand that at last – I have learned that *life is this way* and the rest is painted bread [an illusion]. If I felt better healthwise one could say that I am happy – but this thing of feeling such a wreck from head to toe sometimes upsets my brain and makes me have bitter moments.' Frida and Diego needed each other, and life at the Casa Azul was a calmer affair now. Extended by Diego and decorated by Frida, the house became a little world in

Above: 'Frida with the Olmec statuette', photographed by Nickolas Muray in 1939. Frida arranged the details of her everyday life with the deliberateness of a theatrical set: the blue wall, the pink flowers in her black hair and the geometric orange trim on her traditional Mexican blouse create a kind of *tableau vivant*. Located between the flowers – the pleasures of the moment – and the Mexican mask and heavy, beaten silver bracelet, representing Frida's Mexican roots, the little Olmec statuette sits in her hand like a Mexican mother figure, the source of truth and a reflection of continuity in time.

its own right, a lushly verdant microcosm where a menagerie of pets reigned supreme, members of an extended family humanized by their names: the little deer Granizo, the itzcuintli dogs Señor Xólotl, Señorina Capulina and Señora Kostic, the parrot Bonito, the eagle Gertrude Caca Blanca and the monkeys Fulang-Chang and el Caimito, not to mention the turkey hens, the doves and the fish. The more constrained she felt by the deterioration of her health, the more Frida sought to enrich this world. Each day she set the scene for her life with Diego, going to the market to buy some new object, something traditionally crafted, for the house, and turning each meal into a piece of art, the table itself into a still life, a painting constantly renewed for her husband's delectation.

A Heavy Loss

Frida's father died in his sleep on 14 April 1941, towards the end of his sixty-eighth year. He had been living with his daughter Matilde on Avenida Hidalgo, in Coyoacán, for eight years. After his wife had died, he had given up his photography, becoming less sociable and less communicative, tending to keep himself to himself, though he still took great care over his appearance, judging from the family photographs. On her way through Coyoacán in 1932, the year that Frida's mother died, Lucienne Bloch noted in her journal: 'Her father is a dear, very fussy, deaf and shabby and Schopenhauerish.' She mentions his delight at the comparison and his love of chess; they played a few games together, which distracted him from the troubles hanging over the house – the beautiful house in brilliant blue with pink borders, with its green

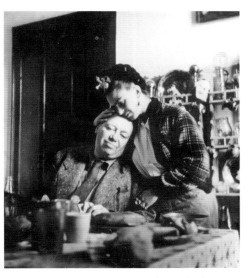

Below: Diego and Frida in the kitchen at the Casa Azul after they remarried, two battle-worn old soldiers after handing in their arms. Married, separated, remarried, the legendary couple known latterly by their Christian names alone, 'Diego and Frida', owed their longevity to their almost maternal connection to one another, each taking it in turns to act out the role of parent and child. In the photograph Frida seems to be enveloping Diego with her love and he smiles like the contented baby in the painting *Diego and I* of 1949.

The Casa Azul is situated on the corner of Calles de Londres and Allende, Coyoacán. It was built by Frida's father three years before she was born. The walls are painted in brilliant cobalt blue (supposed to ward off misfortune), with red and green for the window frames, doors and borders. A little pyramid in the garden served as a support for a collection of pre-Columbian statuettes. It was here, among the tropical trees and the murmuring fountains, that Frida picked flowers to put in her hair and fed the fish and the birds, while reigning supreme back in the kitchen, aided by the faithful Eulalia and Chucho, to whom she was affectionately known as La Niña Fridita. During the recent celebrations surrounding the centenary of Frida's birth, the press announced the discovery of two 'secret rooms in the Blue House', where an extraordinary number of objects had been walled up for fifty years: 22,105 documents, 5,387 photographs, 168 dresses and 11 corsets, 212 drawings, rough sketches and copies by Diego and 102 by Frida, 3,874 magazines and similar publications and 2,170 books.

shutters and central courtyard full of cacti, orange trees and Aztec idols. The death of Frida's father against the backdrop of war in Europe and Nazi Germany left Frida feeling desperately at sea. She confides to Eloesser, in a postscript to the same letter of July 1941: 'My father's death has been horrible for me. I think that's why I'm rundown and why I lost quite a bit of weight. Do you remember how sweet and good he was?'

Anahuacalli, the Pedregal Pyramid

Both Frida and Diego confessed to feelings of helplessness at around this time. While Frida had been knocked sideways by the loss of her father, Diego was deeply troubled by the recent news of Germany's invasion of Russia. He also felt isolated. He had left the 4th International and was the butt of regular attacks by

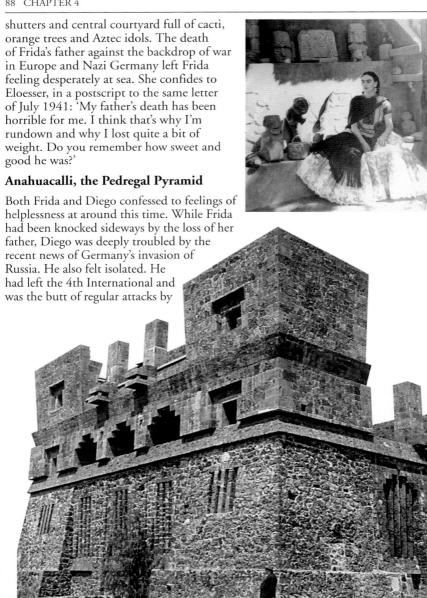

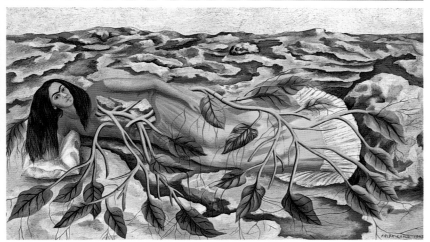

the Communist Party, and now lacked any kind of structure to help him channel his beliefs in practical ways. They both needed a project and, in 1942, they began planning the construction of a building – a kind of museum and temple combined – to house the extraordinary collection of pre-Hispanic archaeological artefacts that Diego had been collecting since his first return from Europe, in 1910. Anahuacalli, the 'house of Anáhuac' in Nahuatl, was built of lava rock in the form of a pyramid, on the grey volcanic earth at Pedregal, not far from Coyoacán, and combines Aztec, Maya and 'traditional Rivera' styles. Frida donated the land, having sold her flat on Avenida Insurgentes to raise the initial capital and corresponded with patrons, collectors and representatives of the state in order to raise the balance. Planned by Diego and designed by his daughter, the architect Ruth Rivera, with Frida's enthusiastic support, Anahuacalli was to serve as a metaphor for the life of a man who had become a national monument, and marked for both artists the start of greater public recognition.

Frida's painting *Roots* (1943) sealed this union, conveying the artist's own connection with nature and the earth, with Pedregal, with Mexico and with Diego

Opposite, top: Frida poses with her collection of pre-Hispanic art in front of the pyramid in her garden at Coyoacán, *c.* 1952–53. Sitting straight-backed in her plaster corset, she looks a bit like a statue herself.

Opposite, bottom: Diego standing in front of Anahuacalli, his massive frame dwarfed by the size of the building. He began building his temple–museum with Frida's help in 1942 at Pedregal.

Above: The arid landscape of Pedregal also forms the backdrop for Frida's *Roots* (1943).

himself. In it we see Frida stretched out on the ground dressed in her Tehuana costume, with leafy green stems full of sap emerging from her chest and taking root in the arid, fissured landscape: the artist's own body is linked to the chain of life on a piece of land chosen by Diego to unite past, present and future.

Public Recognition in Mexico

In 1943, Diego and Orozco joined the company of the 'immortals' at the Colegio Nacional, created by a government anxious to affirm the unity of the country and its culture. Frida's reputation too had been boosted by her reception in the US, Paris and London, and she was now an established figure of Mexican culture.

She participated in numerous group exhibitions over the course of the 1940s, beginning with the International Exhibition of Surrealism, which opened on 17 January 1940 at the Galería de Arte Mexicano, run by Inés Amor. Organized by André Breton, the Peruvian poet César Moro and the Austrian painter Wolfgang Paalen, the exhibition

Below: Interior of the Galería de Arte Mexicano during the International Exhibition of Surrealism in January 1940. Surrealism was an intellectual straitjacket that fitted neither Frida's work nor her personality: she was much too anchored in the physical realities of life to be called a Surrealist, as this page from her accounts book for the year 1947 demonstrates.

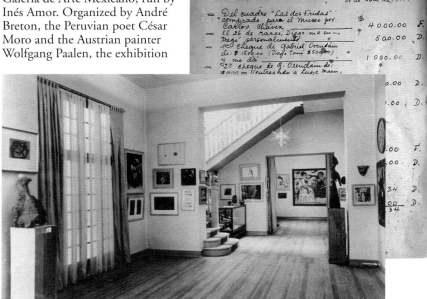

aimed to create a link between Mexico and the European movement and was the artistic event of the year. Frida showed her two large-format works *The Wounded Table* (1940) and *The Two Fridas* (1939), but continued to defend her artistic independence in the fiercest terms, affirming in a letter to a friend, the art historian Antonio Rodríguez, in 1952: 'Some critics have tried to classify me as a Surrealist, but I do not consider myself to be a Surrealist…. Really I do not know whether my paintings are Surrealist or not, but I do know they are the frankest expression of myself…. I detest Surrealism. To me it seems to be a decadent manifestation of bourgeois art, a deviation from the true art that the people hope for from the artist…. I wish to be worthy with my painting, of the people to whom I belong and to the ideas that strengthen me…. I want my work to be a contribution to the struggle of the people for peace and liberty.' She also showed *The Two Fridas* at the retrospective 'Twenty Centuries of Mexican Art', organized by the Museo de Arte Moderno in Mexico City, which bought the picture in 1947 for 4,000 pesos. And in 1942 she was elected a member of the Seminario de Cultura Mexicana, a body of artists and intellectuals whose mission was to promote Mexican culture. The same year, her former fiancé, Alejandro Gómez Arias, wanted to make her a founder member of the Colegio Nacional, but the nomination was turned down because she was a woman.

In 1946, Frida was one of six artists to receive a government grant. She was also awarded a prize, worth 5,000 pesos, by special agreement of the President and

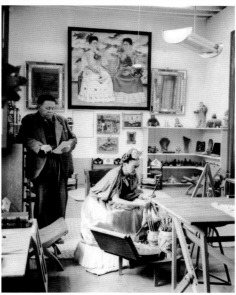

Above: Frida and Diego, in Frida's studio in the Casa Azul in 1945, with *The Two Fridas* gazing out above their heads and representing the artist's sense of her duality. The space is immaculately tidy, a model of German orderliness. Thanks to this and to the bright artificial lighting and the drawing tables, it reminds us of her father's photographic studio.

the Minister of Public Education, for her painting *Moses (Birth of the Hero)* at the annual art exhibition at the Palacio de Bellas Artes.

Moses (Birth of the Hero)

It was a lunch with one of her 'protectors' and patrons, the engineer José Domingo Lavín, that provided the inspiration for what may be considered as Frida's masterpiece, *Moses (Birth of the Hero)* (1945). Lavín showed her his newly acquired copy of Sigmund Freud's *Moses and Monotheism*, Frida asked if she could borrow it, took the book away and, three months later, the picture was finished. 'I read [Freud's *Moses*] only once, and I began to paint the picture with the first impression it gave me. Yesterday, as I wrote these words for you, I reread it, and I must confess to you that I find the painting very incomplete and rather different from what the interpretation should be of what Freud analyzes so marvellously in his *Moses*. But now, there is nothing to be done, neither to take away from it nor to add to it, so I'll tell you about what I painted just as it is and about what you can see here in the painting. Of course, the main theme is "MOSES" or the birth of the HERO. But I generalized in my way (a very confused way) the deeds or images that impressed me the most as I read the book. As for what is there "on my account", you can tell me whether I put my foot in it or not.'

Frida and *los Fridos*

Frida's philosophy of life was very much her own. In 1943, she began communicating it to her students at the School of Painting and Sculpture, unofficially known as 'La Esmeralda', which fell under the umbrella of the Ministry of Education and where she taught alongside artists as distinguished and diverse as María Izquierdo, the French poet Benjamin Perret and Diego himself. Frida taught there three days a week, for a total of twelve hours, for which she was paid a salary of 252 pesos. But she gave '*los Fridos*', as they dubbed themselves, much more than those twelve hours a week. Her arrival at the school was typically spectacular. 'I remember her entering the school of

'I must confess to you that I find the painting very incomplete and rather different from what the interpretation should be of what Freud analyzes so marvellously in his *Moses*.'
Frida Kahlo, 1947

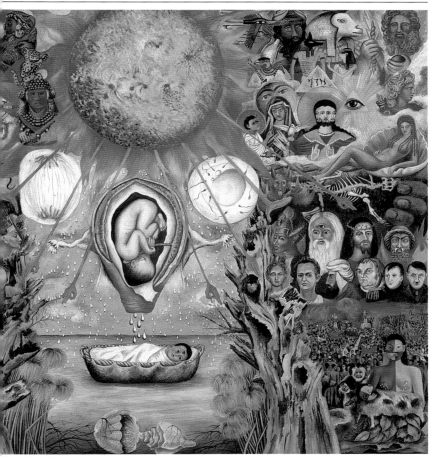

Painting and Sculpture, "La Esmeralda", for the first time. She appeared there all of a sudden like a stupendous flowering branch because of her joyfulness, kindness, and enchantment. This was owed, surely, to the Tehuana dress that she wore, and that she always wore with such grace. The young people who were going to be her students…received her with true enthusiasm and emotion. She chatted with us briefly after greeting us very affectionately, and then

Above: Like Sigmund Freud and Virginia Woolf, Frida was obsessed by the question of origins. After reading Freud's *Moses*, she started work on a painting simply entitled *Moses (Birth of the Hero)* (1945), now regarded as a masterpiece.

immediately told us in a very animated way: "Well, kids, let's go to work: I will be your so-called teacher, I am not any such thing, I only want to be your friend, I never have been a painting teacher, nor do I think I ever will be, since I am always learning.'

So there was nothing academic about Frida's style of teaching. Instead of working from models in a studio, she improvised. She took her students to visit her own home and her garden, took them to the markets and the shanty towns, to archaeological sites, and even to a *pulquería* (a bar serving the Mexican drink *pulque*). Her intention was simply to put them in touch with life, to make them look at life. ' "*Muchachos,*" she would announce, "locked up here in school we can't do anything. Let's go into the street. Let's go and paint the life in the street,'" recalls another of her students, the painter Fanny Rabel. Frida didn't influence her students by her manner of painting, but by her manner of living, of looking at the world, at people and art, according to Rabel; she got them to see and to understand a certain beauty about Mexico that they wouldn't have registered themselves. The grand finale of these open-air workshops was the inauguration of the 'La Rosita' *pulquería* frescoes, on the corner of Calle de Londres, where Frida and Diego had obtained authorization for the students to paint the walls facing on to the street. It was a huge event, more like a fiesta, attended by crowds of people, with poets, painters and artists competing with sonnets, *corridos* and *zapateados* music to the sound of groups of mariachis hired for the occasion. Safely launched on their artistic careers, *los Fridos* later formed the association of 'Young Revolutionary Artists', whose shared ideal was to bring art to the people.

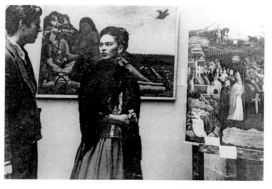

Below: Frida at an exhibition of paintings by Arturo Estrada, one of *los Fridos* and one of her favourite students, *c.* 1947. Frida encouraged her students to find their inspiration out in the street, rather than in art galleries.

Opposite: The artist in Toluca market, handing coins to some children. She felt a deep affinity with the poor people of Mexico and would regularly treat those she met in the street to cigarettes and cinema tickets – a few puffs of smoke and a bit of reverie, in a life for which she never lost her appetite, though she knew its trials only too well. Market fruits sometimes went straight from the kitchen to the studio, to be represented in voluptuous images like this one, entitled *Pitahayas* (1938).

The Broken Column

Frida was no longer able to sit or stand and, in 1944, a new orthopaedic surgeon, Dr Zimbrón, prescribed the use of a steel corset and a course of complete rest. 'Each day I am worse,' she wrote to Dr Eloesser, on the eve of her thirty-seventh birthday, 24 June 1944. It was her fifth month confined to bed. The instrument of her torture is precisely represented in *The Broken Column* (1944), where pain and eroticism are evenly balanced in the depiction of a naked and weeping Frida. This strange equilibrium produces an image that combines suffering with perfect beauty, providing a source of delight to the spectator. Only Frida's original culture has a name for this 'pleasure in pain' – this *Schmerzlust* – which she

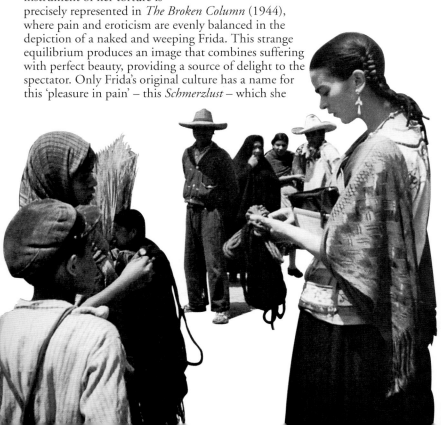

would also have imbibed from her Catholic mother, and the question arises as to whether Frida may in a sense have been 'exploiting' her physical suffering. The eminent Dr Eloesser was convinced that the majority of her operations were futile and attributed her desperate reliance on medical help to a psychological syndrome that impels the patient to seek one operation after another as a means of becoming the focus of attention and an object of love. It was a technique that Frida regularly tested out on Diego, who could lay claims at least to conjugal longevity, if not fidelity. Closer to our time, the psychiatrist Claude Wiart, in the article he devoted to Frida Kahlo's diary, gives us an insight into the true nature of her illness, pre-dating even the accident of 1925, attributing it to 'the terrible and progressive gangrene that affected her right leg and led to surgical interventions and amputation, a gangrene no doubt due to spina bifida, a malformation of the spinal column dating back to her development in the womb'. The adult Frida tucked up in her hospital bed, refusing anaesthesia unless her sister Cristina was there to hold her hand, and whose pain Diego soothed by singing lullabies, evokes a much earlier scene – the baby Frida abandoned to the care of her two elder sisters by a depressive and inconsolable mother. *The Broken Column* and, following it, *Without Hope* (1945), *The Wounded Deer (The Little Deer)* (1946) and *Tree of Hope, Stand Fast* (1946) were vehicles for channelling and expressing her medical ills, when she was not directly using her succession of plaster corsets as a support for her works.

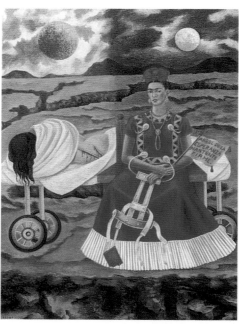

Below: *Tree of Hope, Stand Fast* (1946). Frida had recently undergone a bone graft operation at New York's Hospital for Special Surgery when she painted this double portrait of herself against a fissured landscape. She is lying on a stretcher, at the edge of an abyss, with the wounds in her back exposed. Her alter ego is sitting very upright, dressed in a sumptuous blood-red dress and holding a banner on which are written the words 'Tree of hope, stand fast'.

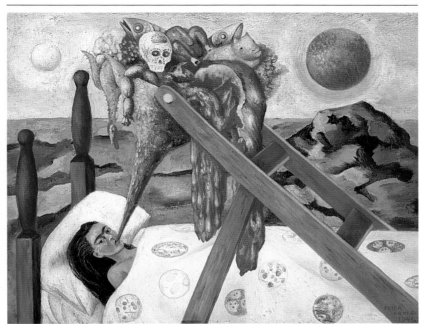

She wrote to her patron Eduardo Morillo Safa on 11 October 1946 to let him know that she had almost finished his first painting, describing it as 'nothing but the result of the damned operation'. That 'damned operation' was the arthrodesis she had asked an orthopaedic surgeon in New York, a Dr Wilson, to perform on her in June: it involved grafting fragments of bone taken from the hip on to four damaged vertebrae, separated by metallic plates. Frida spent two months in New York's Hospital for Special Surgery, where, to help with the pain, she received injections of morphine sufficient to leave her addicted for the rest of her life. On her discharge from hospital, she returned to Mexico.

Diego and I

In the most clearly autobiographical of his murals, *Dream of a Sunday Afternoon in Alameda Park* (1947–48), Diego represents Frida as a maternal figure

Above: In *Without Hope* (1945), we see the same arid, grey landscape (Pedregal) where, only two years earlier, Frida depicted herself taking root in a vigorous and seductive image of interactive fecundity. Here, she is a patient spewing out her guts on to the easel where she would normally be working on her painting: the process of sublimation is turned on its head and the artist's body empties itself of contents that are simply terrifying. By contrast with the rest, the skull seems almost reassuring in its familiarity.

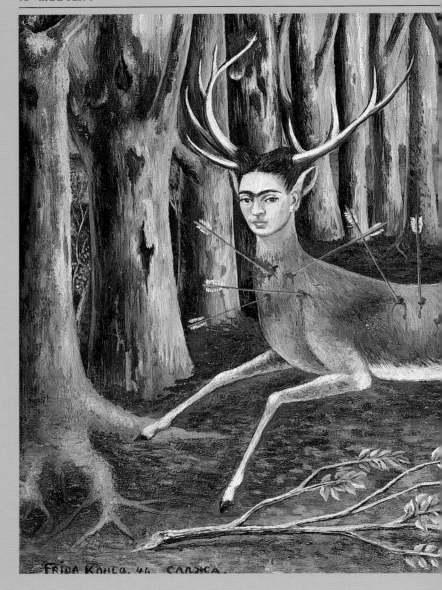

In *The Wounded Deer (The Little Deer)* (1946), Frida gives the animal her own face, which turns towards the viewer with an expression of nobility and dignity, like an icon. The head is crowned with antlers and the body of the deer has been pierced with nine arrows, which will slowly kill it – a symbol of the emotional pain inflicted by Diego's numerous liaisons. Frida is drawing here on Aztec mythology and the creation of abstract and composite entities, half human, half beast, in order to illustrate notions of continuity and rebirth. Contemporary Mexican culture remains for the most part underpinned by the belief system of the indigenous peoples which sees all the components of the natural world as interconnected, and Frida is demonstrating her own engagement with that universe. According to the Aztecs, certain animals were endowed with a special symbolism and every newborn possessed a non-human double. Frida, too, saw herself as a being with the capacity for metamorphosing.

standing protectively close to the figure of Diego himself as a young boy. On her side, Frida refers to her love obsessively, recreating the presence of her wandering husband in painting after painting, linking their two faces in the double portrait *Diego and Frida*

Below: *Self-portrait as a Tehuana (Diego in My Thoughts)* (1943).

Opposite: *Diego and I* (1949).

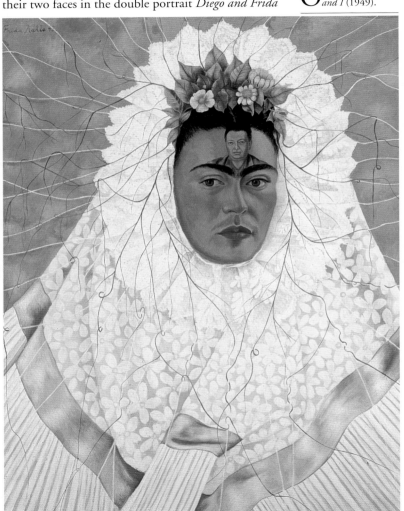

1929–1944 (1944) or inserting Diego's face inside her own in *Self-portrait as a Tehuana* (1943) and *Diego and I* (1949), and holding his body in her arms, naked and white like a baby, with the eye of wisdom on his forehead, in *The Love Embrace of the Universe, the Earth (Mexico), Myself, Diego and Señor Xólotl* (1949), where she herself appears as the daughter of the Earth and the Universe, each held by the other in a succession of embracing arms. And when she is not celebrating Diego in her paintings, she is evoking his presence in words.

Frida negotiates between absence and presence, interior and exterior, the woman imprisoned in her corsets and the man free to make multiple conquests, endeavouring to represent a love that is eternal and impossible. She acknowledges 'Diego, I'm alone' and provides her own response to this, a few pages earlier, like the narrator of Proust's *In Search of Lost Time*, waiting in bed for his mother's goodnight kiss:

'You are present, intangible, and you are the entire universe I create within the space of my room. Your absence is revealed, trembling, in the ticking of the clock, in the pulsation of the light; you breathe through the mirror.'

Wearing her hair loose or adorned Tehuana style, Frida is obsessed by thoughts of Diego, her 'eye of wisdom'.

Diego beginning
Diego constructor
Diego my baby
Diego my boyfriend
Diego painter
Diego my lover
Diego 'my husband'
Diego my friend
Diego my mother
Diego my father
Diego my son
Diego=Me=
Diego Universe
Diversity in unity
Why do I call him My
Diego? He never was
nor ever will be mine.
He belongs to himself.
 Frida Kahlo, *Diary*

Painting under Demerol

The bone graft had not been a success and in early 1950 Frida had herself admitted to the ABC Hospital in Mexico City, where she was to spend the next year. It was almost certainly the beginning of the end. Diego took a room next to hers and this stint in hospital turned, in Frida's own words, into a party: 'I never lost my spirit. I always spent my time painting because they kept me going with Demerol, and this animated me and it made me feel happy. I painted my plaster

corsets and paintings, I joked around, I wrote, they brought me movies. I passed three years [one, in fact] in the hospital as if it was a fiesta. I cannot complain.' She was under the care of Dr Juan Farill, one of Mexico's top surgeons, who performed a new series of bone grafts and to whom she dedicated her *Self-portrait with the Portrait of Dr Juan Farill* (1951) by way of thanks. The painting shows Frida in a wheelchair with her brushes in one hand and her heart as a palette, next to the portrait of the man of whom she says in her diary: '[He] saved me. He gave me back the joy of life.' She painted lying in bed for the most part, using groupings of objects, fruits and flowers to produce a series of still lifes, one of which (painted in 1952) she calls *Living Nature*, or *Naturaleza viva* in its Spanish equivalent, rejecting the dead connotations of the *naturaleza muerta* or 'still life'. The drugs she was taking, in particular the Demerol, caused her to swing between euphoria and despair, also affecting the steadiness of her hand and consequently the precision of her brushstrokes. Her style, which had been as meticulous as a miniaturist's, became more relaxed as a result. The *Portrait of My Father* (1951) is one of the works from this period. Pictured in front of his enormous camera covered in its black cloth, Guillermo Kahlo has a slightly desperate look in his eyes – something we begin to note with Frida too. There is a kind of feverishness to her activity around this time, which flowed over into political zeal. Her still lifes are scattered with doves and flags, and Frida made an active commitment to peace – the meaning of the German word (*Friede*) from which her name was derived. She had been readmitted to the Communist

B elow: Frida in the ABC Hospital in Mexico City, holding a candy skull with her name on it, November 1950.

O pposite: Frida in her wheelchair, posing for Diego for the last time, at the Palacio de Bellas Artes. He had been commissioned to paint a portable mural for the exhibition 'Twenty Centuries of Mexican Art', which was due to tour the whole of Europe. He could choose his subject but had just 35 days to complete 40 m² (48 yd²). The result was

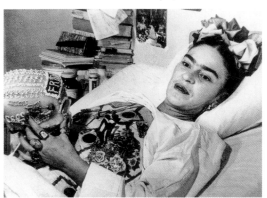

Nightmare of War, Dream of Peace (1952), which unites the figures of Frida, Stalin and Mao, John Bull, Uncle Sam and Marianne (alias the French Republic).

O verleaf: Pages from Frida Kahlo's *Diary*.

Party in 1948 and, wanting to do something practical, she rallied her remaining strength and helped to collect signatures for the International Peace Congress, which opposed nuclear testing by the imperialist great powers – a role as political activist which Diego captured in *Nightmare of War, Dream of Peace* (1952) at the Palacio de Bellas Artes.

Final Homage

A year before Frida died, the photographer Lola Álvarez Bravo, aware that her friend's death was imminent, enlisted Diego's support in a decision to pay homage to Frida's work. In April 1953, in her Galería de Arte Contemporáneo, she organized the first solo exhibition of Frida's work to be held in Mexico. The invitations, which read a little like a billet-doux, were written by Frida herself:

At the private view in Mexico City, congratulations came pouring in: the Soviet ambassador, the Polish and Czech representatives and the President of the Mexican Committee for Peace were all united in their praise. But Diego learnt from the exhibition's organizer, the composer Carlos Chávez, Director of the Instituto Nacional de Bellas Artes, that his mural would not be leaving the country because of the risk that it might cause offence and upset relations with Mexico's powerful friends.

Niño mio— de la gran Ocultadora—

Son las seis de la mañana
y los guajolotes cantan,
Calor de humana ternura
Soledad acompañada—
Jamás, en toda la vida
olvidaré ~~tu~~ tu presencia.
Me acogiste destrozada
~~Y~~ me ~~devolviste~~ integra ~~entera~~.
En ésta ~~tierra~~ pequeña tierra
dónde pondré la mirada?
¡Tan inmensa tan profunda!
Ya no hay tiempo ya no hay ~~nada~~
~~distancia~~. Hay ya solo realidad.
Lo que fué, fué para siempre!
Lo que es, son las raíces,
que se ~~asen~~ asoman ~~hijas~~ transparentes
~~en árbol~~ transformadas
~~eternos~~ En árbol frutal eterno
~~tus~~ frutas ya ~~dan~~ dan aromas
~~y~~ ~~tuas~~ tus flores. dan su color
creciendo con la alegría/de

Coyoacan D.F.

PARIS

8 de Dic 19 48 N.Y.

'With friendship and love
born from the heart
I have the pleasure of inviting you
to my humble exhibition'.

Frida was in a particularly bad way on the evening of the private view, so Diego simply arranged for her four-poster bed to be moved, complete with accessories, and placed in the middle of the gallery. The paintings were then re-hung around it. Frida's spectacular arrival – by ambulance, with the sirens going – was witnessed by an astonished gathering of guests and journalists. She was installed on her bed, heavily doped with painkillers and decked out like a shrine, to receive the congratulations and good wishes of the crowd, and such was the press around her bed there seemed to be a risk she might suffocate. 'It was all theatre,' commented her friend Raquel Tibol – effective theatre, too, because the exhibition was a resounding success, causing ripples even beyond Mexico's borders. The gallery received calls from abroad and by agreement with the artist – as surprised by this surge of interest as Lola Álvarez Bravo herself – it was decided that the exhibition should run for an extra month.

'I am DISINTEGRATION'

Frida now needed round-the-clock care from a team of nurses, and Diego had started painting watercolours again (sometimes as many as two a day) in order to pay for her medical expenses. Then, a few months after the exhibition, in August 1953, Dr Farill pronounced his verdict: Frida's right

> I was sick for a year. Seven operations on my spine. Doctor Farill saved me. He gave me back the joy of life. I'm still in a wheelchair, and I don't know how soon I'll be able to walk again. I'm wearing a plaster corset, and although it's a terrible drag, it does help to relieve my back. I don't have any pain. I'm just drunk with… tiredness and, naturally, very often feeling desperate. Desperate in a way I can't describe. And yet I want to live. I've started painting again.'
> Frida Kahlo

Pies para qué los quiero
Si tengo alas pa' volar.
1953.

Opposite: The cover of Frida's *Diary* and a page from it. The Spanish reads 'Feet, why do I need them if I have wings to fly?'

Left: For the opening, on 13 April 1953, of her first and last solo exhibition to be held in Mexico during her own lifetime, Frida was taken from the ambulance and positioned on her four-poster bed in the midst of her works – like a saint in a shrine, a living relic. The gallery owner, Lola Álvarez Bravo, explained later: 'They had just performed a bone graft on her, but unfortunately the bone was in poor condition and had to be removed. I realized that Frida wouldn't live much longer. I think that people should be honoured while they're alive and can still benefit from it, and not once they're dead.' This photograph shows well wishers at Frida's bedside. From left to right: the singer Concha Michel, Antonio Peláez, Dr Roberto Garza, Carmen Farell and Dr Atl, another legendary artist associated with the Mexican Revolution. He too had just had a leg amputated and had arrived on crutches.

leg needed to be amputated just below the knee. She wrote in her *Diary* 'Yo soy la DESINTEGRACIÓN' ('I am DISINTEGRATION'), drew a series of broken statues, and later on asked: 'Feet, why do I need them if I have wings to fly?' She became apathetic and withdrawn, unable even to tolerate Diego's presence, profoundly wounded, in her body but also in terms of her perception of beauty and harmony, both feminine and artistic. Profoundly devalued, as she saw it. She rallied one more time, however, learning to walk with an artificial leg, making jokes and having boots made for her in red leather – but it was the last battle. 'Thank you to myself and to my tremendous will to live surrounded

by all those who love me and for the sake of all those I love,' she wrote in her *Diary*, on 27 April 1954, clearly in an elevated mood. She was eager to get back to work, and by tying herself to her wheelchair with a belt, she was able to paint *Marxism Will Give Health to the Sick* and *Frida and Stalin*, reaffirming more fervently than ever her belief in the salvational aspects of Communism, clinging to her political ideal as others might to a religious conviction, before leaving on her easel a dirty and unfinished portrait of the Soviet leader – whether the product of physical weakness or ultimate doubt, who can say?

13 July 1954

On 2 July 1954, Frida took part with Diego in one final Communist demonstration, this time against the overthrow by the CIA of the democratic government of Guatemalan president Jacobo Arbenz Guzmán. It was to be the couple's last appearance together

in public – Frida, in her wheelchair, at the head of the crowd, exhausted but still just managing to raise a banner bearing the dove of peace in her heavily bejewelled hand, while Diego placed his own protective hand on her shoulder.

Frida was recovering from pneumonia and had left her bed against the advice of the doctors. She clearly suffered a relapse now. Aware herself that the end was near, she drew a hovering angel splotched with black in her *Diary*: 'I hope the leaving is joyful,' she writes, 'and I hope never to return.' She died at the Casa Azul, where she was born, during the night of 13 July 1954, shortly after her forty-seventh birthday. In the evening she had given Diego a ring for their silver wedding anniversary, over a month early: 'I asked her why she was presenting

Left: Frida's determination was exemplary. Right to the end, she fought for what she believed in, leaving her bed to go and demonstrate with Diego just eleven days before she died.

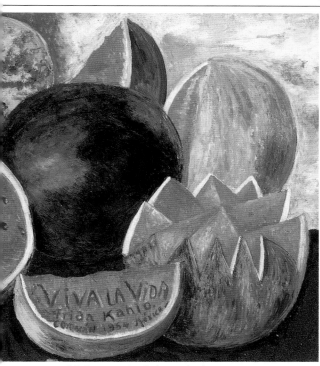

Left: Frida's oeuvre was a constant balancing act between life and death, and as if in conclusion – as if she were taking one last bite out of life, sinking her teeth into the juicy flesh of a watermelon – she leaves us this still life (1954) bearing the slogan '*VIVA LA VIDA*' in the exposed flesh of the fruit. She left no children, but her painting communicates a love of life intensified by the awareness of its brevity and a constant negotiation with death.

Below: Frida's body lying in state at the Palacio de Bellas Artes, 14 July 1954, covered with a red flag emblazoned with a hammer and sickle. Her life was over, but her work would live on.

it so early', he says, 'and she replied: "Because I feel I am going to leave you very soon."'

Diego is said to have been so distressed after the ceremony at the crematorium that he grabbed a handful of Frida's ashes and swallowed them. He bequeathed the Casa Azul to the Mexican nation and died himself three years later.

DOCUMENTS

Correspondence

Frida Kahlo was a great letter writer. Her writings reveal her avant-garde ideas, the intensity of her feelings and all that she suffered physically, giving us a better insight into her personality than any biography.

To Alejandro Gómez Arias

[Coyoacán] 29 September 1926
[...] Why do you do so much studying? What secret are you after? You'll get the answer from life soon enough. I know everything already, without reading or writing. Just a short time ago, barely even a few days, I was still a child and the world around me was a world of colours, and hard, tangible forms. It was all a mystery. There was something hidden, and to me it was just a game trying to guess what that something was. If only you knew how terrible it is knowing everything all of a sudden, as if the earth had been lit by a flash of lightning. Now I live on a planet of pain and it's transparent like ice; it's as if I'd learnt everything there was to learn all in one go, in the space of a few seconds. My female friends and acquaintances have turned into women gradually, but I aged in a single instant, and today everything is gentle and clear. I know that there's nothing else behind all this, that if there were anything else I would see it [...].

Themes touched upon in this letter were to be elaborated on in future paintings such as *Fulang-Chang and I* (1937).

To Alejandro Gómez Arias

[San Ángel?] 12 October 1934
Alex,
There was a power cut, so I had to stop painting the *moninches* [Frida's word for the monkeys]. I carried on thinking about the wall decoration separated by *another wall of* wisdom. My head is stuffed full of tiny creatures, microscopic spiders and the like.... I think we'll have to make the wall microscopic too; otherwise, it'll be hard to achieve the illusion. And anyway do you think all that silent wisdom can be contained in such a limited space? [...] *This is the big* problem and it's up to you to solve it with an architectural perspective, seeing that, as you say, I'm incapable of organizing anything in a *big reality* without getting it wrong immediately. Either I've got to hang dresses up in the air, or I've got to bring far-away stuff dangerously and disastrously close. You'll sort all that out with a ruler and a compass.

Did you know that I've never seen a jungle? So how am I supposed to paint a jungle background full of insects? It's just a joke! But I'll do what I can, and if you don't like it you'll just have to destroy everything once it's been done and painted. But the construction is going to take so long we won't even have time to think about its destruction.

I haven't been able to sort out the procession of tarantulas and the rest

because I reckon the wall is going to need so many coats of paint that it would all just end up being painted over. [...]

I'll call you tomorrow. I'd really like it if you wrote sometimes, even if it's just a few words. I don't know why I'm asking, but I do know that I need you to. Will you?

To Diego Rivera

New York, 23 July 1935

[...] a certain letter that I happened to discover in a certain jacket belonging to a certain gentleman, and which came from a certain young lady living a long way away, in ugly old Germany, and who, I imagine, must be the same person that Willi Valentiner took it into his head to send over here for 'scientific', 'artistic' and 'archaeological' purposes ...made me really mad, and jealous too, if I'm honest.... Why am I so sensitive and so small-minded that I can't see that these letters, these flings with the first bit of skirt, with your English...teachers and your gipsy models, your 'willing' assistants, your students passionate about 'the art of painting', your 'ministers plenipotentiary from faraway places', are just passing affairs, and when it comes down to it you and I love each other to distraction, and even if we have to put up with endless outbursts from one another, doors banging, furious insults and phone calls from the other side of the world, we will always love each other. I think the problem is that I'm rather blunt and perhaps the tiniest bit spiteful. Everything that's happened, and kept happening, in the seven years we've been living together and all my ranting and raving has helped me to see more clearly that I love you more than my own life, and that even if you don't love me the same way you do love me a

little...don't you? And even if you don't, I can still hope that you do, and that's enough....

Love me just a tiny bit. I adore you,
Frida
(Copied by Bertram D. Wolfe and conserved in the B. Wolfe Collection)

Private Diary

'There is an element of light-heartedness and humour in the way that Frida Kahlo looks at life. It transcends her politics and even her aesthetics. The Diary *is the best example of her gift for writing, a funny, bawdy, playful, lively style of writing that makes Frida such an attractive and cheerful person despite everything she suffered.' So writes Carlos Fuentes in his preface to the published edition of Frida Kahlo's diary. She wrote the diary between 1944 and 1954, recording her memories and thoughts with no attention to chronology. It was only published in 1995.*

Diego, My Newborn

This love letter, addressed to Diego, is the first in a long series in the Diary *and reveals the couple's powerful attachment to one another.*

Diego. The truth, the real truth, is that I don't want to speak, or sleep, or listen, or love. But to feel myself enclosed – beyond time and magic, and without fear of the blood – inside your own fear, and your anguish, the very sound of your heart. Madness which I know, if I asked it of you, would only sow seeds of unease in your silence. I ask you for violence, wildness, and you give me your sympathy, your light and your warmth. I'd like to paint you, but I don't have the colours because they fill up my confusion, which is the concrete form of my great love.

F.

Each moment, he is my child, my newborn, at the least, every day, moment of my self.

Ink, Blood, Smell

This entry provides one of Frida's clearest statements regarding her own creativity. Ink is likened here to blood.

Who would believe that the stains live and facilitate living? Ink, blood, smell. I don't know which ink to use, what imprint is struggling to survive in that particular form. I respect its insistence and I shall do what I can to escape my world tinted words – free land, my land. Distant suns that call to me because I'm part of their nucleus. Idiocies. What would I be without absurdity and transience? 1953 for years now I have understood the materialist dialectic.

Stalin Has Left Us

September, night time. Water fallen from the sky humidity of you. waves in your hands. matter in my eyes. calm, violence of being. of oneself, being two, not wanting to cut off. Plant – lake – bird – rose with the four winds. blood river arm, sun song kiss. ruin tears sisters. strange understanding. That's the

way life will be. glass – magic sea.
Delaware and Manhattan NORTH
Valley of dream. light. song. gold
dream child silk. light simple song.
laugh – he is everything. her. them. me.
we are a line a single line from now on.
STALIN (1953) left us on 4 March
MALENKOV is astounding the
revolutionary world which is my world.
Long live Stalin. Long live Malenkov.

Origin of *The Two Fridas* = Memories

Frida describes in detail her 'descent' into a world where she meets her imaginary friend or alter ego. The theme of the artist's double is embodied in the painting The Two Fridas *of 1939.*

I must have been six when I had an
imaginary, and very intense, friendship
with a little girl…of about my own age.
I would breathe some 'mist' on the
window of what was then my room
(it looked out on to Calle Allende), on
one of the bottom panes of glass. And
I would draw a door with my finger….
And, in my mind, I would escape
through that 'door', with a great rush of
pleasure and a terrific sense of urgency,
and cross the space that lay between me
and a dairy called 'PINZÓN'…. I'd go
in through the 'O' of PINZÓN and
(ahead of my time) I'd sink *down into the
earth*, where 'my imaginary friend' was
always waiting for me. I have no memory
of what she looked like, or what her
colouring was like. But I know that she
was cheerful – and that she laughed a lot.
Though she didn't make a sound. She
had a lithe little body and danced as if
she didn't weigh a thing. I followed all
her movements and while she danced
I told her my secret problems. I can't
remember what they were now. But in

my own voice I filled her in on everything
that was happening in my life…. When
I got back to the window, I went through
the same door that I'd drawn on the
pane. Though when that was, and how
long I'd spent with her, I don't know. It
might have been a second. Or thousands
of years…. I was happy. I wiped away the
'door' with my hand and it 'disappeared'.
I would run, with my secret and my
happiness, right to the end of our patio
and, in a corner (always the same one),
at the foot of a big cedar, I would shout
and laugh…. Amazed at finding myself
alone with my great happiness and the
brilliant memory of that little girl. 34
years have passed since I enjoyed that
magical friendship, and whenever it
comes into my mind it's just as real
again and its echo resonates at the heart
of my world, louder and louder.

A Communist

In this extract, Frida gives a Marxist interpretation of her creative universe.

4 November 1952
Today more than ever I feel a sense of
companionship. For 20 years, I have
been a Communist. I know. *I have read
conscientiously* [crossed out] the principal
origins mixed up with ancient roots.

I have read the History of my country
and of almost all other nations. I already
know their class struggles and their
economic struggles. I have a clear
understanding of the materialist dialectic
of Marx, Engels, Lenin, Stalin and Mao
Tse-tung. I love them because they are
the pillars of the new Communist world.
I understood the mistake Trotsky was
making when he first arrived in Mexico.
I have never been a Trotskyite. But
at that time, in 1940 – I was simply
supporting Diego (on a personal level).

Political fervour. But it's important to remember that I've been ill since the age of six and that I've really enjoyed very little good HEALTH during my life and so been useless to the Party. This is 1953. After 22 operations I'm feeling better and I'm going to be able to help my Party from time to time. It's true I'm not a worker, but I am an artisan – And an unconditional ally of the revolutionary Communist movement. For the first time in my life, my painting is an attempt to help the line set out by the Party. REVOLUTIONARY REALISM. Before that my unique and earliest experience was myself. I'm merely a cell in the complex revolutionary mechanism of nations for peace and of the new nations, the Soviet – the Chinese – the Czechoslovak, the Polish – with whom I'm personally linked by blood. As I am with the indigenous population of Mexico. Among those great multitudes of Asiatic peoples there will always be dear faces – Mexican faces – with dark skins and beautiful, inexpressibly elegant features, and the blacks, who are so beautiful and so brave, will have been liberated already. (Mexicans and blacks dominated by capitalist countries, especially North America – USA and England.) Three marvellous comrades have come into my life – Elena Vazquez Gómez, Teresa Proensa and Judy (the latter was my nurse in fact). The other two are really astonishingly intelligent and sensitive in the revolutionary sphere, quite apart from the fact that all three have had a share in improving my health. They are very friendly with Diego and great friends of mine.

Friday 30 January 1953
despite being ill for so long, I'm feeling tremendous joy in BEING ALIVE DYING Coyoacán 4 March 1953 THE WORLD MEXICO THE ENTIRE UNIVERSE has lost its equilibrium with the loss (departure) of STALIN. I've always wanted to know him personally, but it's not important any more. Nothing is immutable everything can be revolutionized – MALENKOV

An Artistic Recipe

Frida demonstrates her technical know-how here, giving the recipe for a medium based on dammar.

Mix 4 equal parts egg yolk pure linseed oil
egg yolk = pure linseed oil = mixture of dammar and turpentine = water
'dammar' dissolved in turpentine and distilled water with disinfectant I use = concentrated aldehyde 1/2 gram per litre of water
dammar steeped in lemon and turpentine for 8 to 10 days
separate egg white from yolk thoroughly
1 – Emulsify ingredients
2 – Grind colours into emulsion
3 – For a glossy texture, use up to twice as much dammar
4 – For completely matte texture, use up to 3 times as much water.

'You Welcomed Me When I Was in Pieces'

This was written in 1938, during Frida's affair with the photographer Nickolas Muray in New York. It was written on a separate page that was later inserted in the diary.

My child – from the great magician PARIS – Coyoacán D.F. 8 Dec. 1938 N.Y.
It is six in the morning and the turkeys are singing,

warmth of human affection
Company in solitude –
Never, in all my life,
shall I forget your presence
You welcomed me when I was in pieces
and made me one again, whole
On this little earth
where shall I let my glance rest?
So immense so deep!
There's no time left, there's no more
[crossed out] distance. There's only
the reality what has been has been so
for ever! What exist are the apparent,
transparent roots transformed into an
eternal fruit tree. Your fruits are already
giving off their perfume, your flowers
are showing their colour as they grow
with the joy of the wind and the flower,
and your joy. Name of Diego. Name
of love. Do not let the tree that loves
you so much go thirsty, the tree that has
hoarded your seed, that has crystallized
your life at six in the morning
your Frida 8 Dec. 1938 aged 28
Do not let the tree whose sun you are go
thirsty, the tree that has hoarded your
seed
'Diego' is a name of love

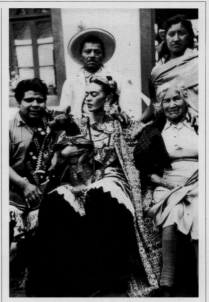

Thank You

*Nearing the end of her life, Frida
experiences a moment of pure delight and
expresses her gratitude for all that Diego, the
doctors and her friends have done for her.*

27 April – 1954
I've pulled through OK – I've made
a promise never to slip back, and I'm
going to keep it.

Thank you to Diego, thank you to my
Tere, thank you to Gracielita and to the
little girl, thank you to Judith, thank you
to Isaura Mino, to Lupita Zúñiga, thank
you to Dr Pamon Parrés, thank you to
Dr Glusker, thank you to Dr Farill, to
Dr Pole, to Dr Armando Navarro, to Dr
Vargas. Thank you to myself and to my
tremendous will to live surrounded by
all those who love me and for the sake of
all those I love. Long live joy, life, Diego,
Tere, my Judith and all the nurses who
have taken such wonderful care of me
during my life. Thank you for the fact
that I'm a Communist and have been
all my life. Thank you to the Soviet
people, to the Chinese people, the
Czech people, the Polish people and the
Mexican people, especially the people of
Coyoacán, where my first cell was born,
conceived at Oaxaca, in the belly of my
mother, who was born there, and who
married my father Guillermo Kahlo –
my mother Matilde Calderón, Oaxaca's
little brown bell. Magical afternoon
spent here in Coyoacán; Frida's room,
Diego, Tere and I. Señorina Capulina
Señor Xólotl Señora Kostic

Frida Kahlo, *Diary*

Ill Health

'I've had 22 operations in the course of my life', says Frida Kahlo in her Diary. *Frida's condition not only affected her day-to-day life, the physical realities of which emerge from her medical file, but also prevented her from having the child she so longed for. Her reaction to both is revealed through her art.*

Motherhood

As early as 1932, Kahlo had expressed something of the conflict between art and motherhood when she depicted herself caught between palette and fetus in a lithograph responding to her abortion that year. A second pregnancy the same year, while she and Rivera were living in Detroit, threw her into an agony of indecision about whether to try and carry the child to term and a cesarean delivery or to have another abortion: "In the second place I am not strong and the pregnancy will weaken me more," she wrote in a letter to her doctor:

> I do not think that Diego would be very interested in having a child since what preoccupies him most is his work and he is absolutely right. Children would take fourth place. From my point of view, I do not know whether it would be good or not to have a child, since Diego is continually traveling and for no reason would I want to leave him alone and stay behind in Mexico, there would only be difficulties and problems for both of us….

Miscarriage solved the problem and in *Henry Ford Hospital* (1932) Kahlo depicts herself naked on a hospital bed, bleeding onto a white sheet. The veinlike ribbons she holds against her swollen stomach terminate in objects symbolic of her emotions at the time of the miscarriage, one of which is a fetus. Torn between her recognition of Rivera's childlike need for her and her desire to bring life into the world, Kahlo would try three more times to have a child, meanwhile expressing her fear of barrenness in paintings dominated by immense empty plains and dry, cracked earth. Painting became her antidote: "My painting carries within it the message of pain … painting completed by life. I lost three children…. Paintings substituted for all this. I believe that work is the best thing."

Constantly aware of the relationship between her own experience of her body and her painting, absorbed by the act of creating out of suffering, she left at least one image of the physical act of childbirth that in its frankness is almost unique in the history of Western art. In *My Birth* (1932), she depicts a female body in the act of childbirth from a directly frontal position. Between the woman's spread legs appears the head of the child Frida, bathed in blood and apparently lifeless. A sheet, wrapped like a shroud, hides the woman's head and upper body. Above the bed the image of a weeping Madonna, her body pierced by daggers, joins the lament. At the

bottom of the canvas a scroll stands ready to receive an inscription of supplication and thanksgiving like those found on the retablos that influenced so much of Kahlo's work. But here there is to be no divine intervention, no joyous outcome, no message of thanksgiving, and the scroll is left blank.

Kahlo's awareness of the relationship between her experience of her body and her painting led her to affirm that she painted only her own reality. Exaggerating that reality, she placed her body at the center of the polarities that governed her life and her awareness: art and nature, pain and salvation, birth and death. She shared the belief of Surrealists like Masson and Bellmer, and near-Surrealists like Bataille and Leiris, that fertile eroticism and death are always coexistent: "That is to say," wrote Masson, "…[that] eroticism and death are always coexistent. That is the grandeur of eroticism." In Kahlo's work this belief arises, not from the ancient Greek myths promoting the eternal and cyclical nature of life that powerfully influenced Masson and Bataille, nor from Freud's casting of this awareness into the language of a new psychological reality, but from her own cultural heritage and her identification with the Mexican belief in the indivisible unity of life and death. *The Dream* (1940) shows Kahlo sleeping in bed below a grimacing skeleton clutching a bouquet of lavender flowers in its arms. Wires and explosives encircle the skeleton's form, turning an image of death into a threat of annihilation. In the bed below, vines printed on the yellow bedspread sprout leaves that encircle the head and shoulders of the sleeping Frida. As is frequently the case in the work of the women artists, the language of generation is that of nature and the cycles of the earth's renewal, rather than that of erotic desire….
The surfaces of Kahlo's paintings are jewellike, their forms precise and suffused with rich deep light and brilliant color. The impression is always one of confronting life, and there is a diffused sexual energy, even in the face of a specific imagery of pain and death. Her view of the universe was one of a "harmony of form and color" in which "everything moves according to only one law—life," and it is the search for this intangible law that lies at the heart of her painting.

Whitney Chadwick,
*Women Artists and the
Surrealist Movement*,
Thames & Hudson, 1985

Medical Report

The author of this report, Henriette Begun, was a doctor from Berlin and a militant Communist who emigrated to Mexico in 1942. The report was almost certainly written after Frida's first consultation, in 1946.

Frida Kahlo: Born 7 July 1910 [*sic*]. Parents deceased. German father, Mexican mother.
Father: Epileptic fits since age 19; probable cause: trauma resulting from a fall. Death of a heart attack at age 74.
Mother: Seems always to have enjoyed good health. Five children, one stillbirth. From 45th year (menopause?) suffers fits similar to the father's. Deceased aged 59 during a gallbladder operation. Breast cancer discovered six months before her death.
Elder sister: Hysterectomy due to presence of cysts. Ovarian insufficiency.
Second sister: Oophorectomy (both

ovaries) due to presence of cysts. Ovarian insufficiency. Three spontaneous miscarriages at six weeks.
Third sister: Dies of pneumonia a few days after birth.
Younger sister: Two healthy children. (The only sister to have given birth normally.) Partial removal of pancreas at age 29 (Dr Gustavo Baz).
Patient's previous medical history:
1910–1917: Normal birth. During childhood: measles, chickenpox, frequent tonsillitis. Normal growth and weight.
1918: Violently strikes a tree stump with right foot. Since then: slight atrophy, retraction and deformation of foot. Variously diagnosed as poliomyelitis and as a 'white swelling'. Treatment: heliotherapy and calcium. Patient leading a normal life at the time, playing sport, etc. Normal psychology. No pains or particular problems.
1925: Menarche. Normal.
1926: Accident resulting in the following injuries: fracture of third and fourth lumbar vertebrae, triple fracture to pelvis, approximately eleven fractures to right leg, dislocation of left shoulder, stomach wound due to metal rod entering left side and exiting by the vagina, causing damage to left lip of vulva. Acute peritonitis. Cystitis. Catheter used for several days. Three months in Red Cross Hospital. Fracture to lumbar vertebrae not detected until Dr Ortiz Tirado takes over patient's care and immobilizes her for nine months using a plaster corset. After wearing this corset for three or four months, patient experiences the sensation that her whole right side has 'gone to sleep'. This sensation lasts for more than an hour. Treatment involves needling and massage, and symptom does not recur. Following removal of the corset, patient

begins to live a 'normal' life again; but since then has experienced a 'permanent feeling of tiredness' and intermittent pains in her spine and right foot.
1929: Marriage, normal sexual relations. Falls pregnant in first year of marriage. Dr J. de Jesús Marín performs an abortion due to unfavourable position of pelvis. Wassermann and Kahn tests for suspected syphilis; negative results. Permanent tiredness; weight loss.
1931: In San Francisco, California, under the care of Dr Leo Eloesser. More tests carried out, in particular Wassermann and Kahn. Results this time slightly positive. Several months' treatment using neosalvarsan method. Treatment abandoned. Cerebrospinal fluid not analysed. Wassermann and Kahn tests again negative. The same month, pains in right leg intensify; deformation of right foot and leg muscles much more marked; tendons of right foot contract, greatly inhibiting normal walking. Dr Eloesser diagnoses congenital deformation of the spine and regards consequences of accident as of secondary importance. X-rays demonstrate severe scoliosis and absence of intervertebral disc and significant loss of space between third and fourth lumbar vertebrae. Analysis of cerebrospinal fluid with negative results. Wassermann and Kahn tests: negative. Koch test: negative. Continuing tendency to spinal fatigue. A small trophic ulcer develops on right foot.
1932: In Detroit, Michigan, under the care of Dr Pratt at the Henry Ford Hospital as a result of a second pregnancy and spontaneous miscarriage at four months, despite continual bed rest and various treatments. New Wassermann and Kahn tests: negative results.

Analysis of cerebrospinal fluid: negative. Trophic ulcer resists treatment.

1934: Third pregnancy. In Mexico. Dr Zollinger performs abortion at three months due to infantilism of ovaries. Appendicectomy. First operation on right foot: removal of five phalanges. Wounds very slow to heal.

1935: Second operation on right foot: several sesamoid bones discovered. Healing again very slow (almost six months).

1936: Third operation on right foot: removal of sesamoid bones. Sympathectomy performed. Healing once again very slow. Trophic ulcer persists. Since then: nervous irritability, loss of appetite and persistent tendency to spinal fatigue; brief periods of respite only.

1938: In New York. Consults neurologists, rheumatologists and dermatologists. No improvement in condition until taken on by Dr Glusker. Succeeds in sealing trophic ulcer with different treatments, including use of electrical currents. Large calluses appear on soles of her feet. More tests: Kahn and Wassermann negative.

1939: Paris, France. Nephritis due to coliform bacteria, accompanied by high fevers. Persistent tendency to spinal fatigue. Depression leads to consumption of large quantities of alcohol (almost a bottle of cognac a day). In Mexico, Dr Farril prescribes complete rest and requires her to wear a 20kg weight to stretch her spine. Examined by several specialists who each independently recommend an operation using the Albee method, also recommended by Dr Albee himself in a letter to the patient. Drs Federico Marín and Eloesser are opposed to the idea. A mycosis develops on the fingers of the right hand.

1940: Transported to San Francisco, California, where Dr Eloesser takes over her care: complete rest, high-calorie diet, no alcohol, electrotherapy, calcium treatment. Second lumbar puncture: negative result. Lipiodol injected in view of X-rays. Patient's condition relatively stable, returns to normal life more or less.

1941: Feels exhausted again, complains of constant fatigue in back and acute pains in arms and legs. Weight loss, general debility and disrupted menstrual cycle. Consults Dr Carbajosa, who prescribes hormone therapy: menstrual cycle normalized and regression of dermatosis on right hand.

1944: Fatigue and pains in back and right foot seriously aggravated in course of this year. Examined by Dr Velasco Zimbrón, who prescribes complete rest and wearing of a steel corset. Gains some relief from this, but pains continue. When corset is removed, she feels unsupported, as if no longer able to stand on her own. Still no appetite, rapid weight loss, six kilos in six months, suffers dizzy spells and has to stay in bed. Slight fever (37.5 to 37.9 C). Seeks advice of several doctors. [...]

1945: Decision taken for first time to raise her right shoe (by two centimetres) to compensate for shortness of the leg.

She is given a new plaster corset (Dr Velasco Zimbrón), but can only tolerate it for a few days due to intense pains in her spine and right leg. Lipidiol, injected during each of the three lumbar punctures, *was not extracted*, causing intracranial hypertension, headaches and shooting pains in the spine. Symptoms aggravated by even slight emotional upset. General debility.

1946: Dr Glusker recommends that patient visit New York and consult Dr Philip D. Wilson, a surgeon specializing in spinal problems. Leaves for New York in May. Undergoes thorough examination by Dr Wilson and other neurologists. All strongly recommend procedure to strengthen her spine and Dr Wilson performs operation in June of same year. Four lumbar vertebrae are joined using bone from the pelvis and a metal rod fifteen centimetres long. Patient is confined to bed for three months and recovers well from operation. She is advised to wear a specially designed steel corset for eight months, lead a quiet life and lie down frequently. During first three months following the operation, a distinct improvement is noted, following which the patient no longer manages to respect Dr Wilson's instructions and leads a hectic life resulting in episodes of high nervous tension. She feels as exhausted again as before, suffers same headaches and back pain and loses weight. Megaloblastic anaemia. Mycosis on right hand again. High levels of anxiety and acute depression.

Dr Henriette Begun,
'Medical history of the patient
Frida Kahlo', 1946

Homages

'When Frida Kahlo entered her box, in the dress circle, all the splendours that bedazzled our eyes were eclipsed. The jingling of gorgeous jewelry drowned out the sound of the orchestra, but it was something other than this that made us all look up and register the vision which that incredible hammering of metallic rhythms announced – the revelation of the woman herself, promised not only by the sound of the jewelry but also by that silent magnetism.'

Carlos Fuentes

Pulquería Art

Guillermo Monroy, one of Frida's students, sang this corrido *at the opening of the Fridos' mural exhibition at the 'La Rosita'* pulquería *in Mexico City, 19 June 1943.*

We have had to work hard
to paint La Rosita.
People have already forgotten
the art of the *pulquería*.

Doña Frida de Rivera,
our dear teacher,
says to us: Come on, children,
I will show you life.

Friends of Coyoacán,
if you want to have fun
you'll like La Rosita;
look how lovely she is!

I don't want to get drunk,
or squint or see double;
I just want to be merry,
for that's the poor man's pleasure!

Guillermo Monroy, in Rauda Jamis,
Frida Kahlo: Autoportrait d'une femme,
Presses de la Renaissance, 1985

The Heroic Flower

These lyrical and passionate sonnets were composed for Frida by a long-standing friend, the Mexican poet Carlos Pellicer.

I

If your belly sheltered the prodigious
rose of colours, if your breasts
nourish the land of brown
subsistences with luminous depths;

if your maternal breadth, the nocturnal
rose
of the events of Christmas Eve
drew your own image with serene
disasters across your populous face;
if your children were born at ages
that no one can re-supply in hours,
for they speak of the solitude of
eternities,

you will always be on the living earth,
you will always be a riot full of new
dawns,
you will be the heroic flower of
successive dawns.

(Mexico D.F., August 1953)

II

Like the one, with flowers in her hand,
who lingers to watch a whole nation
so as to offer it her heart, I love you.
(I was never able to be your Good
Samaritan.)

Nothing in our grief was vain;
let them bring the brushes; the first one
stained with blood will tell you, in the
guise of a goldfinch,
about its tear strolling in the plain.

You are pierced all over with carnations.
The brushes set fire to the blood.
A blood-drenched child rises to heaven.

I am camping in an abyss of tenderness,
dry with thirst. Your heart reduced
its height a little, in full flight.

(Villahermosa, Tabasco, August 1953)

Carlos Pellicer, 'Three Sonnets to Frida
Kahlo', in the catalogue for the
exhibition 'Frida Kahlo 1907–1954',
Madrid, 1984

The Departure

Carlos Pellicer gives an emotional account of his last meeting with Frida, a week before the artist's death.

A week before you left, remember? I was
with you, sitting on a chair, right near
you, telling you stuff, reading you these
sonnets that I'd written for you and that
you liked, and I like them too because
you liked them. The nurse gave you
your injection. It was ten o'clock, I
think. You were falling asleep, and you
gestured to me to come close. I kissed
you and took your right hand in my
hands. Remember? Then I put out the
light. You fell asleep and I stayed for
a while, watching you while you slept.
Outside, the scoured and flooded sky
greeted me mysteriously, in a way that
was right. You seemed completely spent.
I confess that I cried in the street, on my
way to catch the bus home. Now that
you're safe at last, safe for ever, I want to
say to you, or rather to repeat, to repeat
… Oh, you know… You, like a garden
trampled by a night without a sky. You,
like a window battered by the storm,
you like a handkerchief dragged through
blood; you, like a butterfly full of tears;
like a crushed and broken day; like a
tear on a sea of tears; singing araucaria,
victorious ray of light on the road of
everyman […].

Carlos Pellicer, in Carlos Monsivais,
Frida Kahlo, una vida, una obra, Consejo
nacional para la Cultura y las Artes,
Ediciones Era, 1992

Testimonies

Frida fascinated everyone who met her. Diego Rivera said 'The great painting that Mexico has produced over the last twenty years is just a backdrop to the painting of Frida Kahlo Calderón, which glitters like a diamond at the centre of a huge jewel', while André Breton described her as 'endowed with all the gifts of seduction'.

'A Ribbon Around a Bomb'

André Breton recalls his first meeting with Frida Kahlo in Mexico.

[...] It was 20 April 1938. She was there, contained inside one of the two cubes – I don't know if it was the blue or the pink one – that make up her transparent house with its garden full of idols and white-haired cactuses like so many busts of Heraclitus and fenced merely with a border of green 'cereus' through whose gaps inquisitive visitors from all over America peek from morning till night and cameras poke, hoping to catch a revolutionary thought like the eagle, unawares, in its nest. Indeed, Diego Rivera is supposed to parade daily from room to room, via the garden, stopping now and then to stroke his spider-monkeys, and via the terrace where a staircase flings itself through the air free of handrails, moving in that beautiful balanced way of his, displaying the physical and moral stature of the great warrior – for he embodies, in the eyes of a whole continent, the struggle brilliantly directed against all the powers of enslavement, in my eyes therefore the most valuable thing in the world – and yet I know nothing to equal in human terms his domestication to the thinking and to the ways of his wife, or in terms of glamour all that attaches him to Frida's magical personality.

I have long admired the self-portrait by Frida Kahlo de Rivera that hangs on a wall of Trotsky's study. She wears a gown of gilded butterfly wings, which is the way she genuinely appears as she draws aside the mental curtain. We are privileged to be present, as in the most glorious days of German Romanticism, at the entrance of a young woman endowed with all the gifts of seduction and accustomed to move in the same circles as men of genius. [...]

My surprise and joy were unbounded when I discovered, on my arrival in Mexico, that her work had blossomed forth, in her latest paintings, into pure surreality, despite the fact that it had been conceived without any prior knowledge whatsoever of the ideas motivating the activities of my friends and myself. Since the beginning of the 19th century, Mexican painting has been more shielded from foreign influence than any other, more profoundly focused on its own resources, and at this present stage in its development, here at the other side of the world, I found the same line of questioning spontaneously emerging: what irrational laws do we obey, what subjective signs direct our actions at any given moment, what symbols, what myths are operating in

this or that collection of objects, this or that web of events, what meaning should we accord to the mechanism of the eye that enables us to switch from the visual to the visionary? The picture that Frida Kahlo was just finishing at the time – *What the Water Gave Me* – unwittingly illustrated something I heard Nadja saying a little while ago: 'I am the thought on the bath in the mirror-less room.'

Nor does this art lack that drop of cruelty and humour alone capable of binding the rare affective potencies which together compose the philtre that is Mexico's secret. The vertigoes of puberty and the mysteries of the generation nourish the inspiration here, which, far from regarding these as the preserve of the mind, as in other latitudes, struts among them with a mixture of candour and impertinence.

In Mexico, I felt bound to say that there seemed to be no painting better *situated* in time and space than this. I would also add that there is no art more exclusively feminine, in the sense that, in order to be as seductive as possible it is only too willing to play alternately at being absolutely pure and absolutely pernicious. The art of Frida Kahlo is a ribbon around a bomb.

<div style="text-align: right">André Breton,
'Frida Kahlo' entry in the 'Mexique'
catalogue, Pierre Colle gallery, 1939</div>

Painting Her Own Life
In this extract from an article published in October 1943, Diego Rivera analyses Frida Kahlo's oeuvre.

The great painting that Mexico has produced over the last twenty years is just a backdrop to the painting of Frida Kahlo Calderón, which glitters like a diamond at the centre of a huge jewel,

a precious thing, clear and hard and sharp-edged. Christ, the Virgin and the Saints have disappeared from the *retablo*, and in place of a single random miracle, it is the one constant miracle that provides the artistic subject: the miracle that resides in the ever-fluid, ever-different, ever-similar life force that manifests in the movement of blood and of the stars. One life contains within it the elements of every life, and by penetrating to its heart, we plumb unfathomable depths, scale vertiginous heights, discover infinite ramifications weaving and extending down the centuries of light and shadow that are LIFE itself.

This is why Frida's *retablo* always paints her own life, or lives – paints every Frida, every one similar to the others, but every one different.

The analytical German Frida, the constructor-destructor, the hallucinating sceptic – inheritor of her father's genes – prevailed over the Spanish Frida and did away with her, allying herself with the indigenous Mexican – and her mother's genes. The wide-flung door of the sky opened on to the wondrousness and implacability of space, and the Sun and Moon simultaneously, above the pyramids, those vast pyramids, microscopic in relation to stars and planets, immense in their system of proportions that are the proportions of the entire universe. The little girl seated at the centre of the world owned a toy, an aeroplane that travelled much faster than light, travelled as fast as imagination-and-reason, acquainting itself with stars and towns before the telescope or the train. Its speed resides in Frida lying on a bed, weeping and alone, in a mechanized world, observing that the life-foetus is a flower-machine, a slow snail, a dummy, a bony armature,

but in appearance only, for in her essential reality she is on the plane of imagination-and-reason, travelling faster than light.

Self-portraits recur but never look alike and each time look more like Frida – Frida constant and changing like the universal dialectic.

The paintings glitter with monumental realism, and occultist materialism is present in the heart sliced in two, the tables running with blood, the bathtubs, the plants, the flowers and the arteries sealed with the artist's own haemostatic forceps.

Monumental realism filters through to the smallest detail: minute heads are sculpted with the brush as if their proportions were not tiny but colossal; and they appear colossal when the magic of a projector magnifies them to the dimensions of an entire wall. When a microphotograph enlarges the background of Frida's paintings, the reason becomes clear: there is something different about the texture of veins and the mesh of cells; various elements are missing – and so a new perception is introduced and the art of painting sees its capital increased. [...]

Frida is unique in the history of art, ready to tear open her own breast and heart to arrive at the biological truth and express how this feels to her. In the grip of reason-and-imagination, which is faster than light, she painted her mother and her nurse, conscious of not really knowing their faces. The wet-nurse wears a traditional Mexican mask made of stone, and her milk glands are clusters of grapes from which milk drips like rain enriching the earth, or like tears enriching pleasure. The mother's face is the face of the *mater dolorosa*. Pierced with the seven daggers of pain, she makes it possible for flesh to open and

the child Frida to emerge – Frida who was the first since that formidable Aztec master working in black basalt to have rendered her own birth in physical form. A birth reproduced by the only woman to have expressed in her art the feelings, functions and creative potential of woman with such extraordinary power. A birth that produced the most painterly of all painters and the best proof of the reality of Mexico's artistic renaissance.

Diego Rivera, *Boletín del Seminario de Cultura Mexicana*, 1943

'Distancing Herself from Ugliness'

It is one thing to be a body, another to be beautiful: Frida Kahlo incorporated this simple reality into her European and also her Mexican heritage. If she succeeded in distancing herself from ugliness, it was in order to observe whatever was ugly, painful or cruel with a more critical eye and to discover her relationship if not with the model of beauty proper to each time (Memling, slenderness? Rubens, curves? Parton, breasts? Bardot, bottom; Mae West and Twiggy), then at least with the truth as expressed in her, in her face and in her body. Horror and suffering can lead us to a true knowledge of ourselves, and through the medium of her art Frida Kahlo appears finally to have accepted her own reality. She becomes beautiful, simply because she establishes the identity of our very being, of our most secret nature. Frida Kahlo's self-portraits are beautiful for the same reasons that Rembrandt's are beautiful. They reveal to us the successive identities of a being still in the process of becoming.

Carlos Fuentes, preface to Frida Kahlo's *Diary*

Diego and Frida

When Frida Kahlo and Diego Rivera married on 21 August 1929, her parents likened it to the union of 'an elephant and a dove'. Though Diego's and Frida's painting was quite dissimilar, it was also complementary. Art and revolution were their only common ground – plus the fact that both pushed the boundaries of conventional behaviour in every way possible.

Opposites

Kahlo's and Rivera's work could not be more different. Working for the post-revolutionary government which hired artists to create murals that would edify the people and give them a pride in their Mexican heritage, he painted monumental murals embracing broad historical and political subjects on vast public walls. By contrast, the majority of Kahlo's paintings are small, extraordinarily personal self-portraits. Although her focus was narrow, she probed deep, and her self-portraits capture universal feelings so vividly that they pull out all our empathy and reveal us to ourselves. Rivera's work, on the other hand, takes in the panorama of Mexico past and present. Its great scope does not make it shallow, but its force and meaning are cumulative. The viewer must look first at one part and then at another to gather a picture of Rivera's intent, whereas Kahlo's impact is immediate, direct, and as centered as an icon.

For many viewers, Rivera's broader, more objective subject matter has, over time, lost much of its relevance. Yet the poetry and human concern that underlie his political message and his formal brilliance remain fresh. Kahlo's message is so clear that most people faced with one of her self-portraits feel that she speaks directly to them. The spouses' creative motivation and processes were different as well. Rivera was the complete professional. He started painting young and had years of academic training both in Mexico and in Europe. He was convinced that making art was his destiny; he put in Herculean hours and it was obvious to everybody that painting was the center of his life. The center of Kahlo's life was Rivera. She taught herself to paint because, she said, she was "bored as hell in bed," and that the accident prevented her from pursuing her studies toward a medical career. She painted when she felt like it, sometimes working hard, other times hardly at all.

Their approaches to work follow male and female stereotypes that prevailed in Mexico (and elsewhere) at that time. Rivera liked to think of himself as both a disciplined worker (a painter, he said, is a worker among workers) and a demiurge; Kahlo preferred the role of the charming amateur who produced little paintings that were both folkloric and eccentric and that fulfilled private needs. Rivera's ambition was as

monumental as his art. Kahlo hid her ambition behind a playful façade. Being married to a famous artist not only gave her access to the art world, it also provided a protective buffer that allowed her, for many years, to avoid the risks and bruises of building a career. Both husband and wife believed their need to paint was a spontaneous urge with a biological basis. Rivera said that for him painting was as natural as a tree putting out flowers and fruit. Kahlo, somewhat disingenuously, said, "The only thing I know is that I paint because I need to, and I paint always whatever passes through my head, without any other consideration." She described her drive to paint as a form of compensation: "Painting completed my life. I lost three children…. Painting substituted for all of this. I believe that work is the best thing." Rivera's purpose was to move the world toward a Marxist state. He said, for example, that he wished his mural cycle at the Ministry of Education (1923–8) "to reproduce the pure basic images of my land. I wanted my painting to reflect the social life of Mexico as I saw it, and through my vision of the truth to show the masses the outline of the future."

Kahlo's and Rivera's reverence for each other's art was a powerful bond. He encouraged (even cajoled) her to keep on painting in spite of the misery of the numerous surgical operations that never healed the damage the accident caused to her back and her right leg. Rivera loved her shockingly self-revealing subject matter, her courage to paint, for example, her own birth or herself in 1932 having the one of the several miscarriages that made her realize that she would never fulfill her wish to bear Rivera's child. When she was depressed after this miscarriage, it was he who

suggested that she paint the important moments of her life on small sheets of tin like the Mexican retablo or ex-voto painters who depict people being saved from accidents or other disasters by a holy intercessor. He also pushed her to show and sell her work. Rivera's support of her art was absolutely essential to Kahlo's continuing artistic endeavor. In a 1943 essay on his wife's relationship to Mexican art, he wrote: "In the panorama of Mexican painting of the last twenty years, the work of Frida Kahlo shines like a diamond in the midst of many inferior jewels; clear and hard, with precisely defined facets…. Frida's art is individual-collective. Her realism is so monumental that everything has "n" dimensions. Consequently she paints at the same time the exterior and interior of herself and the world." Rivera often told friends that Kahlo was a better painter than he was—no doubt his praise was lavish because her painting and the scale of her ambition was so distinct from, and so much smaller than, his own.

In turn, Kahlo thought Rivera was the greatest painter in the world; she called him the "architect of life." Next to his, her own art seemed insignificant; perhaps in part because she did not want to compete with Rivera, she frequently spoke of her work in diminishing terms, as if it were an amusing pastime. She acted surprised when people took an interest in it, and purchases astonished her. "For that price they could buy something better," she would say, or "it must be because he's in love with me." Sometimes she would turn her serious engagement with painting into a joke, for example when she told the writer of a *Detroit News* article entitled "Wife of the Master Mural Painter Gleefully Dabbles in Works of Art,"

that Rivera "does pretty well for a little boy, but it is I who am the big artist."

When it came to his art, or himself, Kahlo passionately defended her husband against all detractors. She was the critic he respected the most, and even if he grumbled at her occasional negative comments, he was apt to make the changes she suggested. For all the extreme contrast between her painting and his, there are many similarities, especially in subject matter. Since he was the older and more experienced artist, the exchanges of influence usually ran from him to Kahlo. Both of them expressed in their work a powerful allegiance to Mexico. Rivera painted the saga of Mexican history, for example in his National Palace murals (1929–35 and 1945) from a Marxist point of view and with an abundance of well-researched detail. By contrast, in works like *My Nurse and I* (1937), in which she imbibes her nourishment from the breast of an Indian wet nurse wearing a Teotihuacan mask, Kahlo made clear her Mexican origins. When she became involved with Rivera Kahlo's art changed dramatically. In her self-portraits she now presented herself wearing Mexican jewelry, hairstyles and costumes, all of which met with Rivera's approval, for, like many artists in post-revolutionary Mexico, he wanted to reaffirm Mexico's indigenous culture. As he put it, "The classic Mexican dress has been created by people for people. The Mexican women who do not wear it do not belong to the people, but are mentally and emotionally dependent on a foreign class to which they wish to belong, i.e., the great American and French bureaucracy." Kahlo also followed her husband's example in painting Indian women and children, as opposed to her earlier portraits of her white middle-class friends. In paintings like *The Bus* (1929), where she juxtaposes a blue-eyed *gringo* holding a moneybag (a motif taken from Rivera's 1928 *Night of the Rich* panel in his Ministry of Education mural) with a Madonna-like, barefoot Indian woman holding a baby wrapped in her shawl, she reveals that she shared Rivera's leftist political sympathies. [...]

On the whole Kahlo eschewed direct political content and painted for a small audience composed mainly of friends. But she did give her work a political inflection in paintings like *My Dress Hangs There* (1933), in which she countered Rivera's contemporaneous mural *Man at the Crossroads*, painted above the main elevator bank at Rockefeller Center, New York, with her own political manifesto. Here she collaged newspaper photographs of breadlines and protests and linked Trinity Church, whose mullions are shaped like a dollar sign, with Federal Hall, whose steps are made of a collaged graph that says "Weekly sales in millions." But the painting's value as propaganda is diminished by her spoof of American values seen in the setting of a golf trophy and a toilet on pedestals. *My Dress Hangs There* is also too personal to carry much political clout. Appalled by the lavish cocktail parties given by the rich while the poor stood in breadlines, Kahlo showed her disdain for Capitalist society by painting her Tehuana dress hanging above Manhattan without herself in it. She wanted to go home to Mexico. Rivera's *Man at the Crossroads* opposed an idealized view of Russian Communism with a negative view of Capitalist New York where police brutally suppress a protest while rich people drink champagne. But

Rivera put an urban worker who looks like a pilot at the controls of history; he wanted to stay in an industrialized country where he thought Marxism would triumph.

In the last two years of her life, 1953–4, when her health was deteriorating quickly, Communism became a kind of religion to Kahlo. Part of her vehemence must have come from her desire to help Rivera gain readmittance to the Communist Party. Kahlo's diary, written in her final decade, is full of professions of Marxist faith, and several of her last paintings show her struggle to find a way to make her art serve the revolution. The problem was that her paintings remained too self-referential to function as political rhetoric, whereas Rivera's murals could give post-revolutionary Mexico a leftist view of the possibilities for social progress.

Kahlo's and Rivera's approaches to other subjects almost always differ along the same lines. Again following cultural stereotypes about differences between men and women, she was more personal and saw the world in relation to herself, specifically in relation to her body. He took in the world with his erudite and deeply curious mind, transforming what he saw according to his elaborate political mindset. Kahlo expressed her feelings in terms of things done to her body. Her flesh is punctured with nails, thorns, and arrows, or it is torn open to extract her bleeding heart. She is always immobile, and her face is a mask of heroic impassivity. When Rivera depicts himself in murals and self-portraits, it is his own visual capacity, his huge, all-powerful eyes that dominate. Kahlo recognized his stress on seeing and knowing by painting her husband with

an extra eye, the eye of superior vision, in his forehead. The only other characters to be blessed with this "eye of supervisibility" are Moses, Buddha, and the sun. Rivera's eyes swept over reality and collected a multiplicity of details to build his vast world view. As Kahlo put it: "His bulging, dark, highly intelligent and large eyes are held in place with difficulty—almost coming out of their orbits—by eyelids that are swollen and protuberant, like those of a frog. They are very much more separate from each other than other eyes. They enable his vision to embrace a much wider visual field, as if they were constructed especially for a painter of spaces and multitudes. Between those eyes, so distant one from the other, one divines the invisible eye of Oriental wisdom."

Hayden Herrera in
*Significant Others: Creativity
and Intimate Partnership*,
Thames & Hudson, 1993

Ritual Exorcism

[…] It was during this time [when Diego was being unfaithful with her sister Cristina] that she produced her most violent pictures. They are cries of pain rather than sequenced thoughts and still very similar to the harsh and brutal images of ex-votos. Childhood and death are bound in these works by an unbearable necessity. The death of young Dimas, one of Frida's Coyoacán friends, whom Diego had painted in the arms of his elder sister Delfina, was for Frida the symbol itself of the Mexican tragedy. She paints the child lying in his ceremonial gown and wearing a satirical paper crown, reminiscent of the victims of pre-Hispanic rituals, a laughable

emblem of the 'royal kingdom' of childhood.

Other children rub shoulders with death and interrogate the adult world in her pictures *Four Inhabitants of Mexico*, painted in 1938 (in response to another painting by Diego), and *Little Girl with a Death Mask*. As a way of banishing her feelings of loneliness and loss, Frida painted scenes that function as a kind of ritual exorcism where blood and wounds represent self-inflicted emotional pain. She exposes her obsession with self-mutilation and her fear of insanity, and images like the severed artery in *The Two Fridas*, the necklace of thorns and the gouged-out organ of *Heart* are a silent testimony to her suffering, statements of fact, both bloody and dispassionate, that seek to attract Diego's wandering eye – while terrifying her contemporaries.

In late 1938, the journalist Clare Boothe Luce, from the American magazine *Vanity Fair*, asked Frida to paint a picture in memory of her friend the actress Dorothy Hale, who had just committed suicide by throwing herself out of the window of a New York apartment block. What Frida actually painted was her own suicide, the suicide she visualized during her darkest moments, after leaving Mexico, perhaps, following the break with Diego. The actress lies on the ground, in her evening dress, wearing – like a final offering pinned over her heart – the same bouquet of roses that Isamu Noguchi used to give to Frida. Blood streams from Dorothy's face down on to the frame. Her friend was appalled by the cruelty of the image, but Frida knew no other way of expressing things. She was committed to truthfulness, and truth could be unsettling, overwhelming:

the suicide of a woman who had no husband, no money and no prospects was bound to jog the world out of its complacency.

For Frida, during this unhappy period, everything served as a pretext for communicating her pain. It was at around this time that she began painting cut fruit, skins off and pulpy insides offered up to the harshness of the light, like those Barbary figs painted in 1937, which were to remain the symbol of her wounded femininity – and which Diego too would be influenced to paint. She represented her life in pictures that were increasingly strange, like *What the Water Gave Me*, of 1938, where the debris of her visions floats in the bathwater swilling around her submerged legs; but also her faith in the magic of her past, in the nutriment sucked from her nurse's breast, that supernatural milk flowing into her mouth drop by drop in the picture *My Nurse and I*, painted in 1937, and uniting her for good with the indigenous American cosmos.

Frida was driven by the need to paint: painting became her only way of surviving the separation from Diego. Though it may have helped to exorcize some of her demons, it could not heal the breach, however, and in late 1939, on her return from Paris, Diego asked for a divorce. The destruction of the couple would sweep everything else in its wake. [...]

Inspirational Magic

[...] Art could never replace the reality of motherhood for Frida, but it helped her to bear the contradiction, the curse, to put it outside herself rather than allowing it to eat away at her. Art connected her rhythm with her animal nature; it was a natural rhythm that had nothing to do with thought (hence the Surrealists' enthusiasm for her painting), an absolute

necessity uniting her with a world from which fate had peremptorily excluded her. Art, childhood, beauty, violence and love were indissolubly linked in the luxury she conjured up around her, the traditional Mexican costumes resembling flamboyant plumage or gorgeous plant forms, the Indian idol mask, the hair braided and tied like the ritual headdress of Tlazolteotl, goddess of the earth, the magic of the natural world surrounding and encompassing, sometimes wounding and torturing her, where tears glitter like diamonds and the red, red blood flows, most precious of liquids.

It was this magic that inspired Frida and kept her alive, and it was this same magic that bewitched and fascinated Diego Rivera, that kept him at her side, despite the temptations and easy conquests which caused him to stray at times. There was a mystery about Frida that baffled and obsessed him, and a feeling of emptiness, of deficiency and disequilibrium, whenever he was apart from her.

J.-M. G. Le Clézio, *Diego et Frida*,
Éditions Stock, 1993

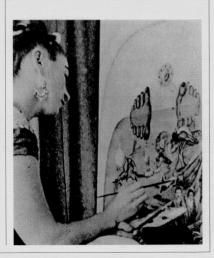

BIBLIOGRAPHY

GENERAL WORKS

– Ankori, Gannit, *Imaging Her Selves: Frida Kahlo's Poetics of Identity and Fragmentation*, Westport (Conn.) and London: Greenwood Press, 2002

– Araceli, Rico, *Frida Kahlo: fantasia de un cuerpo herido*, Mexico: Plaza y Valdés, 1998

– Breton, André, *Surrealism and Painting*, translated from the French by Simon Watson Taylor, London: Macdonald & Co., 1972

– Del Conde, Teresa, *Vida de Frida Kahlo*, Mexico: Secretaria de la presidencia (editorial department), 1976

– Grimberg, Salomon, *I Will Never Forget You... Frida Kahlo to Nickolas Muray*, Munich: Schimer/Mosel, 2004

– Herrera, Hayden, *Frida Kahlo: The Paintings*, London: Bloomsbury, 1991

– Herrera, Hayden, *Frida: A Biography of Frida Kahlo*, London: Bloomsbury, 1998

– Kahlo, Frida, *The Diary of Frida Kahlo: An Intimate Self-portrait*, introduction by Carlos Fuentes, essay and commentaries by Sarah M. Lowe, London: Bloomsbury, *c.* 1995

– Kettenmann, Andrea, *Frida Kahlo, 1907–1954: Pain and Passion*, Cologne, London and Paris: Taschen, 2000

– Maso, Carole, *Beauty is Convulsive: The Passion of Frida Kahlo*, Washington DC: Counterpoint, 2002

– Prignitz-Poda, Helga, Grimberg, Salomon, and Kettenmann, Andrea (ed.), *Frida Kahlo: das Gesamtwerk*, Frankfurt: Neue Kritik Verlag, 1988

– Prignitz-Poda, Helga, *Frida Kahlo: The Painter and Her Work*, Munich: Schirmer/Mosel, 2003

– Saborit, Antonio, *Frida Kahlo*, Mexico: Landucci Editores, 2001

– Tibol, Raquel, *Frida Kahlo, Cronica, Testimonios y aproximaciones*, Mexico: Ediciones de Cultura Popular, S.A., 1977

– Tibol, Raquel, *Frida Kahlo*, Frankfurt: Neue Kritik Verlag, 1980

– Tibol, Raquel, *Frida Kahlo: An Open Life,* translated by Elinor Randall, Albuquerque: University of New Mexico Press, *c.* 1993

– Tibol, Raquel (ed.), *Escrituras Frida Kahlo,* Mexico: Universidad nacional autónoma de Mexico, 2001

– Zamora, Martha, *The Letters of Frida Kahlo: Cartas Apasionadas,* San Francisco: Chronicle Books, 1995

EXHIBITION CATALOGUES

– *Museo Frida Kahlo*, catalogue with texts by Carlos Pellicer and Diego Rivera, Technical Committee of the Diego Rivera Foundation, Mexico, 1958

– *The Frida Kahlo Museum*, catalogue with texts by Lola Olmedo de Olvera, Diego Rivera and Juan O'Gorman, Organizing Committee of the 19th Olympic Games, Mexico, 1968

– *Frida Kahlo, Exposicion nacional de homonaje*, catalogue with texts by Alejandro Gómez Arias and Teresa del Conde, Instituto Nacional de Bellas Artes, Mexico, 1977

– *Frida Kahlo*, catalogue with text by Hayden Herrera, Museum of Contemporary Art, Chicago, 1978

– *Frida Kahlo, 1907–1954. The Collection of Dolores Olmedo Patiño*, Los Angeles, 17 January–29 March 1987 (then San Francisco, San Diego, San Antonio and New York)

– *The Art of Frida Kahlo*, catalogue with an essay by Teresa del Conde and Charles Merewether, Adelaide Festival of Art, Adelaide, South Australia, 1990

– *Frida Kahlo from the Collection Fundación Museo Dolores Olmedo Patiño, Mexico,* The Helsinki City Art Museum, 28 January–24 April 1997; Millesgarden, Sweden, 7 May–24 August 1997; Henie-Onstad Kunstsenter, Oslo, 30 August–26 October 1997; Ordrupgaard, Copenhagen, 4 November 1997– 4 January 1998

– *Diego Rivera et Frida Kahlo*, Pierre Gianadda Foundation, Martigny, 24 January–1 June 1998; Dina Vierny Foundation–Musée Maillol, 17 June– 30 September 1998, RMN–Musée Maillol, Paris, 1998

– *Frida Kahlo*, Museo della Permanente, 9 October 2003–8 February 2004, Silvana/Arthemisia, Milan, 2003

– *Frida Kahlo: la metamorfosis de la imagen/forest of images*, Museo Mural Diego Rivera, 2004–5, Instituto Nacional de Bellas Artes, Mexico, 2005

– *Frida Kahlo*, Tate Modern, 9 June–9 October 2005, Tate Modern Publishing, London, 2005

– *Frida Kahlo*, Bucerius Kunst Forum, Hamburg, 15 June–17 September 2006, Hilmer Verlag, Munich, 2006

– *Frida Kahlo Homenaje nacional 1907–2007*, Museo del Palacio de Bellas Artes, 13 June–19 August 2007, Mexico, Instituto Nacional de Bellas Artes, Editorial RM, SA de CV, Banco de Mexico, 2007

LIST OF ILLUSTRATIONS

Frida Kahlo on their wedding day, 21 August 1929.

37 Frida Kahlo, *c.* 1929, photograph by Guillermo Dávila.

38 Diego Rivera painting the fresco *Allegory of California,* San Francisco Stock Exchange Luncheon Club, February 1930.

39 Diego Rivera and Frida Kahlo in San Francisco, 1930, photograph by Edward Weston.

40 Group portrait with Frida Kahlo, Diego Rivera and Dr Eloesser (left) at the Palacio de Cortés, Cuernavaca, 6 August 1931.

41a *Portrait of Luther Burbank,* 1931, oil on masonite, 85.5 x 60.5 cm. Dolores Olmedo Patiño Museum, Mexico.

41b Frida Kahlo painting *Portrait of Mrs Jean Wight,* San Francisco, 22 January 1931.

42 Frida Kahlo and Diego Rivera on their visit to the Ford Motor Co., Detroit, 1932. Detroit Institute of Arts Collection.

43 *The Dream (Self-portrait Dreaming),* 1932, crayon on paper, 27 x 20 cm. Juan Coronel Rivera Collection, Mexico.

44–45 Diego Rivera, *The Industry of Detroit,* 1932–33, north wall. The Detroit Institute of Arts, Michigan.

46 *Frida and the Abortion (The Abortion),* 1932, lithograph on paper, first edition, 29.3 x 23 cm. Dolores Olmedo Patiño Museum, Mexico.

47 *Henry Ford Hospital (The Flying Bed),* 1932, oil on metal, 30 x 38 cm.

Dolores Olmedo Patiño Museum, Mexico.

48 *Self-portrait on the Borderline between Mexico and the United States,* 1932, oil on metal, 30 x 34 cm. Private collection.

49 Frida Kahlo 16 October 1932, photograph by Guillermo Kahlo.

50a Headlines from *The New York Times,* 10 May 1933.

50b Hugh Curry Jr and Diego Rivera working on the fresco *Man at the Crossroads* at the Rockefeller Center, New York, 26 April 1933.

51a Headlines from *The New York Times,* 16 February 1934.

51b Diego Rivera, *Man at the Crossroads,* 1924, reproduction of the fresco at the Rockefeller Center. Museo del Palacio de Bellas Artes, Mexico.

52–53 *My Dress Hangs There,* 1933, oil and collage on masonite, 46 x 50 cm. Private collection.

CHAPTER 3

54 *Fulang-Chang and I,* 1937, oil on masonite, 39.9 x 27.9 cm. The Museum of Modern Art, New York.

55 Leon Trotsky and his wife are welcomed by Frida Kahlo at Tampico, 9 January 1937.

56–57a View of the house at San Ángel.

57b Diego Rivera, 'Frida Kahlo behind her sister Cristina', detail of the fresco *Mexico Today and Tomorrow,* 1934–35, from the series *Epic of the Mexican People.* Palacio

de Bellas Artes, Mexico.

58a Isamu Noguchi in 1935, photograph by Edward Weston.

58b *A Few Little Pricks,* 1935, oil on metal, 29 x 39.5 cm. Dolores Olmedo Patiño Museum, Mexico.

59 Frida with a bottle of Cinzano, New York, 1935, photograph by Lucienne Bloch.

60 Diego Rivera and Frida Kahlo at an anti-fascist demonstration organized by the Workers' Party, Mexico, 23 November 1936.

61a *Self-portrait Dedicated to Leon Trotsky (Between the Curtains),* 1937, oil on canvas, 87 x 70 cm. National Museum of Women in the Arts, Washington, gift of the Honorable Clare Boothe Luce.

61b Arrival of Leon Trotsky and his wife Natalia Sedova in Mexico, 24 January 1937.

62 *Little Girl with a Death Mask,* 1938, oil on metal, 14.9 x 11 cm. Nagoya City Art Museum.

63 *Four Inhabitants of Mexico,* 1938, oil on metal, 32.4 x 47.6 cm. Private collection.

64–65 *What the Water Gave Me* (entire work and details), 1938, oil on canvas, 91 x 70.5 cm. Private collection.

66 'Frida and Nick', Coyoacán, 1939, photograph by Nickolas Muray.

67a Headline of a manifesto *For an Independent Revolutionary Art,* Mexico, 18 June 1938.

Atelier André Breton Archives, Paris.

67b André Breton, Diego Rivera and Leon Trotsky at 'Mexique', 1938, photograph by Fritz Bach. Atelier André Breton Archives, Paris.

68a Marcel Duchamp in his Paris studio in 1938, photograph by Denise Bellon.

68b Preface to the exhibition catalogue of 'Mexique' at the Pierre Colle Gallery, autograph document handwritten by André Breton, 1938. Atelier André Breton Archives, Paris.

69 Cover of the exhibition catalogue 'Mexique', Pierre Colle Gallery, preface by André Breton, 1938. Atelier André Breton Archives, Paris.

70 *The Frame,* 1937–38, oil on aluminium, glass and wood, 28.5 x 20.5 cm. National Museum of Modern Art–Centre Georges Pompidou, Paris.

71 Frida Kahlo wearing the earrings given to her by Picasso, photograph, no date.

72 *Self-portrait with Itzcuintli Dog,* 1938, oil on canvas, 71 x 52 cm. Private collection.

73 *Self-portrait with Cropped Hair,* 1940, oil on canvas, 40 x 28 cm. The Museum of Modern Art, New York.

74 Frida working on *The Wounded Table,* 1940, photograph by Bernard Silberstein.

75 *The Suicide of Dorothy Hale,* 1938–39, oil on masonite and painted frame, 59.7 x 49.5 cm. Phoenix Art Museum,

INDEX

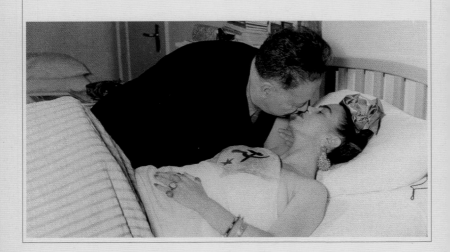

PICTURE CREDITS

AFP/ACME 61b. AFP/El Museo del Barrio 3. AKG-images spine, 7, 61a. AKG-images/Denise Bellon 68a. Artothek/Christie's 62. Atelier André Breton Archives, Paris 67a, 67b, 68b, 69. Schirmer/Mosel Archives 10, 11. Bridgeman-Giraudon 20, 21a, 23, 29, 44–45, 64–65, 75, 76–77, 111a. Christie's images 48. CNAC/MNAM Dist. RMN/Jean-Claude Planchet 70. Collection Detroit Institute of Arts 42. Collection Jacques and Natasha Gelman, The Vergel Foundation 100. Collection Cristina Kahlo 12a, 12b. Collection Juan Coronel Rivera, Mexico/Javier Hinojosa 24–25, 43. Collection Raquel Tibol 17, 18–19b. Private collection 14a, 14b, 19a, 27r, 28, 35, 36, 40, 52–53, 56–57a, 71, 85, 88a, 89, 90l, 92–93, 94, 96, 102, 103, 109, 110, 111b, 119, 123, 135, 142. Private collection/Serge Veignant 101. Corbis/Albright-Knox Art Gallery 1. Corbis/Bettmann 21b, 38, 41b, 50b, 55, 81a. Dagli Orti/The Art Archive 83. Dagli Orti/The Art Archive/Museo Dolores Olmedo Patiño, Mexico 5. Dagli Orti/The Art Archive/Museum of Modern Art, Mexico 78–79. Dagli Orti/ The Art Archive/Museo Frida Kahlo 112. Dagli Orti/The Art Archive/Nicolas Sapieha 87b. Getty Images/Hulton Archives/Stringer 91, 113. Getty Images/Time and Life Pictures/Stringer/Jacqueline Paul 88b. Salomon Grimberg 72. Fritz Henle Estate 95b. Bernard and Edith Lewin, Palm Springs, California backboard. Madison Museum of Modern Art, Wisconsin 95a. Courtesy of Maria Luisa Novelo Archives 37. Alfredo Merino 86. Museo Dolores Olmedo Patiño, Mexico/Javier Hinojosa 9, 34, 41a, 46, 47, 58b, 97. Museo Dolores Olmedo Patiño, Mexico/Serge Veignant 82. Museo Estudio Diego Rivera y Frida Kahlo, San Ángel, Mexico 15, 26–27. Museo Frida Kahlo, Coyoacán, Mexico 16, 90r, 104–5, 106–7, 108a, 108b. Nickolas Muray Photo Archives frontboard, 2, 4, 6, 66, 84. The New York Times 50a, 51a. Courtesy Old Stage Studios/www.LucienneBloch.com 59. Palacio de Bellas Artes, Mexico 51b, 57b. Roger-Viollet 22. Roger-Viollet/Bilderwelt 32. San Francisco Museum of Modern Art 31. Scala, Florence/Art Resource 33. Scala, Florence/The Museum of Modern Art, New York 13, 54, 73. Bernard Silberstein 74. Sipa/AP 60. Sipa/AP/Jose Luis Magana 87a. Smithsonian Archives of American Art, Washington 81b. Sotheby's, New York 63, 98–99. Courtesy of Throckmorton Fine Arts, Inc., New York 30, 49. Edward Weston ©1981 Center for Creative Photography, Arizona Board of Regents 39, 58a. © Museo Dolores Olmedo Patiño Trust 9, 34, 41a, 46, 47, 58b, 82, 97.

ACKNOWLEDGMENTS

The author thanks Juan Coronel Rivera, Hayden Herrera, Carlos Phillips Olmedo and Raquel Tibol, as well as Gaby Franger and Rainer Huhle for their recent discoveries. The works of Frida Kahlo and Diego Rivera are reproduced with the kind permission of INBA, Mexico.

Christina Burrus was born in Munich. She initially studied medicine but developed an interest in the history of art, specializing in German and Austrian Baroque painting. Burrus has organized and commissioned numerous art shows around the world and produced exhibition catalogues. She is also the author of *Art Collectors of Russia: The Private Treasures Revealed* (London: Tauris Parke, 1994).

Translated from the French *Frida Kahlo: 'Je peins ma réalité'* by Ruth Wilson

Library of Congress Control Number: 2007943866

ISBN 978-0-8109-8402-8

Copyright © 2007 Gallimard
English translation copyright © 2008 Thames & Hudson Ltd, London, and Abrams, New York

Frida Kahlo and Diego Rivera works copyright © 2007 Banco de Mexico Diego Rivera and Frida Kahlo Museums Trust, Av. Cinco de Mayo 2, Col. Centro, Del. Cuauhtémoc 06059, Mexico, D.F.

Printed and bound in Italy
10 9 8 7 6 5 4 3 2 1

HNA ▌▐▐▐▐
harry n. abrams, inc.
a subsidiary of La Martinière Groupe

115 West 18th Street
New York, NY 10011
www.hnabooks.com